WALCH PUBLISHING

Daily Warm-Ups

ART

P9-ARQ-269

Shari McMahon

Level I

SUSTAINABLE FORESTRY INITIATIVE

Certified Chain of Custody
Promoting Sustainable
Forest Management
www.sfiprogram.org

SGS-SFI/COC-US09/5501

CURR
N
360
.M63
2005

1 2 3 4 5 6 7 8 9 10

ISBN 0-8251-5388-3

Copyright © 2005

J. Weston Walch, Publisher

P.O. Box 658 • Portland, Maine 04104-0658

walch.com

Printed in the United States of America

Table of Contents

The *Daily Warm-Ups* series is a wonderful way to turn extra classroom minutes into valuable learning time. The 180 quick activities—one for each day of the school year—cover all aspects of a basic art curriculum. They may be used at the beginning of class to get students focused, near the end of class to make good use of transitional time, in the middle of class to help students shift gears between lessons—or whenever you have minutes that now go unused. In addition to helping students warm up and focus, they are a natural lead-in to more in-depth activities.

Daily Warm-Ups are easy to use. Simply photocopy the day's activity and distribute it. Or make a transparency of the activity and project it on the board. You may want to use the activities for extra credit points or as a check on your students' critical-thinking skills as they are acquired and built over time.

However you choose to use them, *Daily Warm-Ups* are a convenient and useful supplement to your regular class lessons. Make every minute of your class time count!

Note: Like many art projects, some of the activities in this book require the use of materials and tools that could be considered hazardous. To ensure a safe environment, set and enforce safety rules in your classroom. Take into account the maturity level of each of your classes when selecting activities. The Teacher's Guide provides some options for modifying activities.

The Elements of Design: Line

Cardboard Printing

- cardboard scraps
- tempera paint
- 9-inch-by-12-inch drawing paper
- heavy shears or mat knife
- flat paint palette

In this exercise you will create a sky and trees using tempera paint and cardboard. Cut about 10 cardboard rectangles of various widths and lengths (no more than 6 inches wide or 6 inches long). Choose a tempera color for the sky. Put small dabs of the paint, plus some dabs of white, on the palette.

Dip the long edge of one of the cardboard strips into the paint. To create sky, drag the cardboard sideways across the surface of the upper two-thirds of the paper. Try dragging the cardboard in different ways to get a skylike effect.

Next, choose colors for the trees and put them on the palette. Drag, stamp, and twist with the narrow edges of the cardboard to create tree shapes across the foreground. Remember that trees are shaped a bit like the letter Y, spreading outward from one thick upright to narrower branches. Use a variety of tree heights to add interest.

1

© 2005 Walch Publishing

Wire Figure Gestures

- armature wire
- wire-cutting shears
- newsprint
- pencil or charcoal

This activity give you practice in using line to express movement and gesture. Your teacher will choose two classmates to serve as models. They will hold a pose for only 10 seconds. It is your goal to capture each pose before it changes.

Begin by loosely dividing your paper into ten thumbnail spaces. In each space, make a quick gesture drawing of the model. Remember, you will only have 10 seconds to sketch! Focus on drawing large general lines that capture the overall pose rather than small areas of detail.

When you have drawn all ten poses, choose your favorite pose. Use armature wire to create a three-dimensional version of the sketch.

2

Daily Warm-Ups: Art

Take a Bite

- eating apple
- 6-inch-by-24-inch drawing paper
- pencil

Place the apple in front of you. Near the left edge of the paper, do a contour-line drawing of the apple. (A contour-line drawing shows an object by drawing its edges or contours without using value or color.) When you have finished the first drawing, take one bite from the apple. Next to the first drawing, draw the apple again with the bite missing. When you have completed the second drawing, take a second bite. Draw the apple again. Continue in this manner until the last drawing shows only the apple core.

Daily Warm-Ups: Art

3

The Elements of Design: Line

Ink Lines

- black ink
- plastic straw
- Bristol board
- newspaper to cover work area
- eyedropper

Use an eyedropper or one end of a straw with a finger capping the opposite end to drop a small drop of ink onto the paper. Blow the ink with the straw, making random ink lines.

Add a second droplet of ink. Try to vary the effect of the ink lines by changing the force of your breath or the size of the initial ink drop.

How much control do you have? Can you intentionally change the direction of a line? Do you see any recognizable images taking form?

4

The Elements of Design: Line

Life Lines

- drawing paper

- pencil

Closely observe the lines on the palm of your hand. Use all or part of what you see to create an abstract design. Add as many or as few lines as you need to break up the paper in an interesting way.

5

Invented Line

- drawing paper

- pencil

Line is one of the most commonly used elements of art. Line can be straight or curved, horizontal or vertical, thick or thin. Line is used to describe the outline of a shape and to show that a shape has volume. Line can be used to show emotion, such as fear, anger, or excitement.

On your paper, use a pencil to invent as many different types of line as you can think of.

6

Daily Warm-Ups: Art

The Elements of Design: Line

Blind Contour Drawing

- drawing paper
- masking tape
- pencil or pen

To create a blind contour drawing, draw while looking only at the object you are drawing, not at the paper.

Begin by taping the corners of the paper down to hold it still. Carefully observe your hand. Note which fingers are higher or lower. Observe the placement of the knuckles. How are the fingernails situated at the tips of the fingers?

Put your hand in a comfortable but interesting pose. Using a pen or pencil, make a blind contour drawing of your hand. Be sure to focus on your hand and not on your drawing.

When the drawing is complete, look at it. How does it look to you? How did you feel while drawing it? Write one or two sentences next to or on the back of your drawing to explain how you felt about the process and how you feel about the results.

7

© 2005 Walch Publishing

When Line Becomes Shape

- six plastic drinking straws

- cotton string or heavy thread

- blunt sewing needle

You have probably tried drawing a three-dimensional shape using lines on paper. In this activity you will use three-dimensional lines to create a shape.

Thread the needle with string or heavy thread. Run the string or thread through six plastic drinking straws to create a tetrahedron—a pyramid with three sides and a triangular base.

If you have difficulty figuring out how to form the shape, draw a three-dimensional pyramid on paper, and then try again.

Daily Warm-Ups: Art

8

The Elements of Design: Color

Complementary Colors

- drawing paper

- pen or pencil

Put a sheet of plain white paper on your desk. Find an object in the room that is either a primary or a secondary color. It could be an item of clothing, a backpack, a book cover, and so forth. Stare at the object without blinking for 10 to 15 seconds. At the end of that time, quickly switch your gaze to the center of the white paper on your desk. Without blinking, stare at the center of the sheet of paper for 5 to 10 seconds. What do you see? Write one or two sentences to explain what you saw.

9

© 2005 Walch Publishing

Color Practice

- drawing paper

- drawing tools (pencil, colored pencil, or marker)

On one sheet of paper, draw the same shape ten times. Choose a simple shape that is easy to draw. Consider simplified worms, turtles, fish, or birds rather than geometric shapes. Draw your chosen shape the same size each time, and try to fill the entire sheet. Color in each shape, using one of the following color schemes in each shape. Keep coloring until you have created all ten color schemes.

- the three primary colors
- the six intermediate colors
- three to five warm colors
- triadic colors
- a gradual change from a dark value to a light value

- the three secondary colors
- analogous colors
- three to five cool colors
- complementary colors
- the color spectrum (ROYGBIV)

How you apply the color within each shape is up to you: be creative!

Color Intensity Practice I

- drawing paper
- colored pencils

Draw three circles in a row across the paper. Choose one color, and use it to fill in all three circles.

Take the complement of the color you chose. (Complementary colors are opposite each other on the color wheel.) Use it to add a light overlay of color to the first circle. Leave the center circle as it is. Use your color's complement to add a heavy overlay of color to the third circle.

Now, look at the three circles. How does adding the complement of a color affect the pure color? Write one or two sentences describing the effect.

Daily Warm-Ups: Art

11

Color Intensity Practice II

- drawing paper
- tempera or acrylic paint
- brush
- wash water
- paper towel or sponge for blotting brush
- newspaper to cover work area

Cover your work area with newspaper. On the drawing paper, paint two squares of the same primary color, with a large white space between them. Next to one of the primary squares, paint a square of its complement. Next to the other primary square, paint a square of one of its related secondary colors.

Look at the two color pairs. Which combination (primary plus complementary or primary plus secondary) appears more intense? Why do you think this is? Write one or two sentences in explanation.

Color Intensity Practice III

- drawing paper
- tempera or acrylic paint
- brush
- water
- paper towel or sponge for blotting brush
- newspaper to cover work area

Daily Warm-Ups: Art

Paint three quarter-sized dots of the same primary color in a row across the paper. Leave large white spaces between the dots.

Around the first dot's edges paint a ring of the color's complement; the result will be a bit like a fried egg. Around the second dot paint a ring of the secondary color to the right of your chosen primary color on the color wheel. Around the third dot paint a ring of the secondary color located to the left of your chosen primary color on the color wheel.

Which primary color dot appears brightest to you?

13

The Elements of Design: Color

Tints and Shades

- acrylic paint
- drawing paper
- palette
- brush
- water
- paper towel or sponge to blot brush on
- newspaper to cover work area

A *tint* is a color that has white added to it. A *shade* is a color that has black added to it. Choose one color on the color wheel. Place a dab of this color on a palette. Place dabs of black and white paint on the palette. Use the pure color to paint a horizontal rectangle on the paper.

Wash and blot the brush well. While the paint on the paper is still wet, dip the brush in the white paint. Use white to tint the paint on the left third of the rectangle. Make the outer edge as white as you can. Blend the color with white toward the inner edge. Wash and blot the brush well.

Now dip the brush in black paint. Leave pure color in the center of the rectangle. Use the black paint to create shades of the color on the right third of the rectangle. Make the outer edge as black as you can. Blend the color with black toward the inner edge.

Making Neutral Colors

- colored pencils
- drawing paper

Using a colored pencil, fill a circular shape with a pure color. Now go over this color with its complement. Keep adding and blending in more of the complementary color until you have created a neutral (gray-brown) color. Create six other neutral colors by blending complements together.

Compare all the neutral gray-browns you created. List the two colors you used to create each neutral color. Make a list of applications where you might use the colors you have created.

Daily Warm-Ups: Art

15

The Elements of Design: Color

T-shirt Design

- drawing paper

- colored pencils or markers

What is it that first attracts you to a T-shirt? Color? Design? Cut? Down the side of a sheet of drawing paper, list ten different color combinations you think would appeal to you in a T-shirt. Next, draw four simple T-shirt shapes on the paper. They can all be the same or you can vary their shape. Create a graphic (it can be as simple as a circle) for each shirt. Use your four favorite color combinations to color in the shirts.

How appealing are your color choices now that you see them on paper? What changes might you make?

16

Landscape Colors

- landscape photograph
- colored pencils
- drawing paper

Color choice and intensity are tools that can help create the illusion of perspective in a landscape drawing or painting. Cool colors (greens, violets, blues) appear to go back in space. Warm colors (reds, yellows, oranges) appear to come forward. This does not mean that you should never use cool colors in the foreground. That is where color intensity (brightness or dullness of a color) comes into play. The farther back a color is in the picture, the duller and less intense it should be.

Look at a landscape photograph. Squint your eyes until it becomes out of focus and the details become less clear. Can you see which areas are more intense?

Choose the three or four most dominant colors that you see in the photograph. Keep in mind color temperature and intensity. Using the sides of the pencils, block in on your drawing paper broad areas of color as they appeared to you when you squinted at the photograph.

17

Photo Match

- glue
- drawing paper
- colored pencils
- half of a magazine photograph

In this activity you will re-create the missing half of a photograph. Look carefully at the half of a magazine photograph you have been given. Glue it to a piece of drawing paper, leaving appropriate drawing space for the missing image half, depending on the orientation of the image.

Observe your half photograph carefully. Use your imagination to complete the other half of the photograph. Try to capture the colors and textures as you see them. Blend to get appropriate values and intensities where necessary. The best result will be achieved through careful observation.

18

Daily Warm-Ups: Art

Color Spinner

- poster board
- paint or markers in primary colors
- scissors
- 12-inch length of cotton string or twine

Cut a 4-inch circle from poster board or other sturdy white stock. Divide the circle into four equal parts. Choose two primary colors. Paint one wedge in one primary color and the wedges on either side of it the other primary color. Paint the wedge opposite the first wedge the first primary color. You should now have four alternating wedges, with wedges opposite each other the same color.

Flip the wheel over. Divide and color the circle in the same way, but swap out one primary color for the color you didn't use. Poke two holes about 1/3 of an inch on either side of the center. Pass one end of a piece of cotton string or twine through one hole. Pass it back through the second hole. Even up the two ends and knot them together. Center the colored spinner in the center of the string. Hold the string with both hands. Twist it, and then gently pull. Watch to see what happens to the colors as the circle spins around. Write one or two sentences to describe what you see.

Daily Warm-Ups: Art

19

© 2005 Walch Publishing

Brown Paper Lunch Sack

- drawing paper
- brown paper lunch sack
- pencil
- viewfinder

Place the opened lunch sack on the table in front of you. Choose a placement that appeals to you. Try looking at the sack from different angles. If the lunch sack is new, do you like its crispness or do you want to crumple it or give it some creases? Is the bag more interesting upright or lying down? Decide how large to draw the bag on the paper to create an interesting placement. Do you want to center the bag on the paper, or draw it so that it appears cropped?

Daily Warm-Ups: Art

Look carefully at the value changes both on the inside and outside of the lunch sack. Squinting sometimes helps you see the changes more easily. Use a viewfinder to check the angles of the sack edges compared to the edges of the paper.

Do a value drawing using pencil. Concentrate on creating the illusion of depth. The more accurately you reproduce the bag's value changes and angles, the better your three-dimensional illusion will be.

20

Pencil Value Scale

- drawing paper
- pencil

How many different values can you get from a pencil? Begin by bearing down very hard. Create a 1-inch square or circle on the paper. Continue creating 1-inch squares or circles, each one lighter than the one before it, until you have created what you feel is the lightest value you can possibly create. Try to create five to eight different values. If time allows, do the exercise again, trying to create more values than on your first attempt.

21

Pen Value Scale

- drawing paper

- pen

How many different values can you get from a ballpoint pen? Begin by bearing down very hard. Create a 1-inch square or circle on the paper. Continue creating 1-inch squares or circles, each one lighter than the one before it, until you have created what you feel is the lightest value you can possibly create. Try to create five to eight different values. If time allows, do the exercise again, trying to create more values than on your first attempt.

Daily Warm-Ups: Art

22

Crosshatch Value Scale

- drawing paper
- pen

Create a ten-point value scale using crosshatched lines. Draw ten 1-inch-square boxes across the paper. In the first box, put crosshatched lines very close together to create a value that appears very dark. Crosshatch inside each box, gradually making your lines farther and farther apart in successive boxes, until the value in the last box appears quite light.

Daily Warm-Ups: Art

23

Stippled Value Scale

- drawing paper

- pen

Create a ten-point value scale using stippling. Draw ten 1-inch-square boxes across the paper. In the first box, put stippling dots very close together to create a value that appears very dark. Stipple inside each box, gradually making the dots farther and farther apart in successive boxes, until the value in the last box appears quite light.

Daily Warm-Ups: Art

24

Color Value

- large flat palette or mixing surface
- white tempera or acrylic paint
- newspaper to cover work area
- paper towel or sponge for blotting
- one color of your choice in tempera or acrylic

- drawing paper
- pen or pencil
- brush
- water

Cover your work surface with newspaper. Place one dab of white paint on a palette. Below this, place a dab of white paint twice as large as the first dab. Below this, place a dab of white paint three times as large as the first dab. Next, choose one color of paint. Add about the same amount to each pile of white paint. Mix each dab well, washing and blotting the brush between values.

How many different values can you mix? Did you produce a dark value? A medium value? A light value? Record each combination for future reference by painting a bit of the color on paper and writing next to it how the color was created.

25

© 2005 Walch Publishing

Landscape Proportions and Value

- pencil
- reproduction of landscape drawing
- drawing paper

Have you ever wondered how artists create landscape drawings that appear to go miles back in space? One way is through the use of proportion. Look at a landscape drawing. What size and value are the objects at the bottom of the page compared to objects in the middle of the page or at the top of the page? Larger, darker objects (the ones that the artist wants you to see as closer to you) are usually located toward the bottom of the page. This is known as the *foreground* of a picture. Objects located in the *middle ground*—the middle of a picture—are smaller and lighter than the objects in the foreground. This helps create the illusion of distance. Objects high up on a page are drawn smaller and lighter again, which makes them appear to be farthest away from the viewer.

Lightly draw a landscape in pencil. Keep objects toward the bottom of the page larger and more detailed than the objects you draw higher up (farther away). Apply appropriate values and clarity of image to the various areas of your drawing.

26

Elements of Design: Value

Ink Wash

- palette with wells
- ink
- brush
- paper towel or sponge for blotting
- newspaper to cover work area
- water

Cover your work area with newspaper. Place a small drop of ink in one well of a palette. Use your brush to place drops of water in the other wells. Place one drop of water in the well closest to the ink, two drops in the next well, three drops in the next, and so on, until each well contains some water.

Dip your brush tip into the ink. Rinse the brush off in the first water-filled well. Repeat, dipping the brush tip in ink and rinsing it in another well each time, until you have created a different value of ink in each well.

Now randomly paint with each of the values. Try placing lighter values on top of darker values, or dropping a blob or painting a line of dark ink onto a wet area of a lighter value. Fill the page with experimental value exercises. Observe each, noticing how your strokes react with one another.

27

Elements of Design: Texture

Simulated or Implied Texture

- drawing paper

- assorted drawing tools (pens, pencils, crayons, markers, and so forth)

Create a texture sampler to use as a reference in future projects. Begin by folding your paper to create many small thumbnails. Fill each small area of the paper with a different group of marks that suggest a texture. Start by using each type of drawing tool in turn. Then try combining them. Look around the room, at your shoes, at people's clothing; there are texture ideas all around you. For example, crosshatching created with a pen might make a good texture for tree bark. Crosshatching created with a crayon has a different look.

Fill each thumbnail completely. When each thumbnail is filled, consider how and where you could use each texture. Write your ideas under each thumbnail or on the back of the paper.

28

Elements of Design: Texture

Tactile Texture

- pie tin
- sand or salt
- toothpick
- unsharpened pencil

When was the last time you played in the sand? Sink your fingers into a tin of sand (or salt, if sand is not available). Start by focusing on the feel of your fingers in the sand. Rub the grains between your fingers. Move your fingers around in the sand.

Now, use your fingers to make drawings in the sand. Experiment. What line quality can you achieve using your fingers? Try using a toothpick or an unsharpened pencil to make lines. How do the lines you made with your fingers compare to the lines you made with a tool?

Make a quick sketch of any designs you particularly like.

29

© 2005 Walch Publishing

Elements of Design: Texture

Drawing How It Feels

- paper
- assortment of drawing tools
- paper bag with an object or objects in it

Reach into the bag. Without looking, feel the object inside. You are going to draw the way the object feels to you. Do not try to guess what the object is and draw what you think it should look like; instead, try to represent the shape and texture you felt.

Before drawing, think about the qualities of the object. Look at the available drawing tools. Choose the tools that will help you represent those qualities best. Then draw how the object felt to you.

30

Elements of Design: Texture

Surface Quality

- brush
- paper
- water
- salt

- watercolors
- paper towel or sponge for blotting
- newspaper to cover work area
- plastic wrap

You can achieve unity in a work of art through a consistent use of surface quality. In this activity you will create a textural background for future use. Choose three analogous colors to work with. Use the wet-into-wet and/or dry-into-wet watercolor techniques. Cover the paper completely with color. Then add interest by scratching into areas with the end of the brush, applying salt, or placing a piece of crumpled plastic wrap on top and moving it around, then lifting it off. You might even try crumpling the entire watercolor, then flattening it out to let the paint pool in the cracks and crevices.

When the background is complete, ask yourself how it could be used. Could you add details without compromising the surface qualities of the piece? Would it be best to cut the painting up and reassemble it in collage form? Jot down five ways you could use the watercolor background.

31

Observing and Re-creating Texture

- drawing paper

- pencil

Careful rendering of an object's surface quality is one way in which artists create believable images. In this exercise you will try to find ways to re-create surface quality. Choose a simple object to draw. Do you see reflected light? Try to create it through value changes. Does the object have a pitted surface? How can you capture that?

Draw a small area of the object only, not the entire object. Be sure to draw your chosen area large enough so that you have room to capture the textural surface qualities.

Daily Warm-Ups: Art

32

Daily Warm-Ups: Art

Glue Texture

- bottle of white glue

- Bristol board or oak tag (white or colored)

In this exercise you will use the bottle of glue as a drawing tool. Create an image or a design of your choice by carefully squeezing the glue. Your design should not be too detailed nor should your lines be too close together. The glue has a tendency to spread a little before it dries, so keeping your lines as fine as possible is a good idea. Avoid squeezing too hard, which can create puddles.

When you are finished with your design or image, place the project in a safe location to dry.

33

Texture Rubbings (Frottage)

- drawing paper

- pencil

- black crayon

What is texture? It is the way an object looks or feels. Looking around the room, find three objects that look as if they have a distinct texture.

Fold your paper into six sections. In one section, draw one of the objects you see from your seat. Now go over to the object, place the paper over it, and rub with the side of a crayon or pencil to pick up the object's actual texture. Use the space next to your drawing for the texture rubbing. Repeat these steps for all three objects.

34

Textured Landscape

- crayons

- drawing paper

Draw a simple landscape with a distinct background, middle ground, and foreground. Use large, open shapes in your drawing, as you will be doing crayon rubbings to fill the spaces.

Now, look around the room for textures to use in your landscape. For example, the sole of a shoe might suggest the rough side of a rocky mountain. Once you have identified actual textures you can use, place your drawing over the item so the textured surface is under the appropriate area of the drawing. Rub gently over the surface of the paper with the crayon to transfer the texture to the paper. Repeat for the other areas in your landscape.

Daily Warm-Ups: Art

35

Bubble Printing

- paint solution in a cup
- newspaper to cover work area
- straw
- drawing or watercolor paper

Have you ever blown bubbles in your milk? This similar technique is a fun way to produce a random pattern of curved lines in various values, which can be used as a background or cut up and made into a collage once dry.

Daily Warm-Ups: Art

36

Using a straw, blow bubbles into the paint solution. When the bubbles crest the top of the container, place the paper quickly on top. This causes the bubbles to pop, leaving their impressions on the paper. Repeat the blowing and popping steps until the paper is filled with bubble prints. Be sure to move the paper to a new area after each print so that you fill the entire paper with prints.

Shadow Tracing

- drawing paper
- Conté crayon, pastel, or charcoal

Look at the shadows cast by the objects near you. Find a shadow that is interesting to you. Place your paper so that the shadow falls across it. Move the paper around until the shadow creates a balanced composition. Trace the shadow twice, on two separate sheets of paper, if necessary. Fill in the shadow area on one drawing. The result is a positive shadow shape. Fill in the negative area around the second shadow drawing. The result will have a very different look.

37

Elements of Design: Shape

Finish the Picture

- the shapes on this page

- pencils

Look at the shapes on this page. What can you turn them into?
Use your pencil to add details to each shape.

38

Daily Warm-Ups: Art

Tool Trace

- tool
- pencil
- paper

Choose one of the tools available for your use with this exercise. Using your imagination, look at the tool. What does it remind you of? What could the tool become if it were to take on a new life? A machine? An animal?

When you have an idea, put the tool on the paper and carefully trace around it. No matter what you decide to turn the tool into, the tool should remain the emphasis of your drawing. Trace the tool more than once if it is much smaller than the paper. Add whatever other details you need to in order to create a new "life" for your tool. Give your new creation a name; write the name at the bottom of your drawing.

39

Four Shapes, Four Looks

- oak tag scraps
- scissors
- pencil
- drawing paper

Cut four small shapes from scraps of oak tag. Divide a sheet of drawing paper into eight rectangular boxes. Place your four shapes inside one of the boxes so that they are spaced apart without touching. Trace the outlines of the shapes onto the drawing paper. Now, place the shapes in another rectangle so that they are just touching; again, trace the outlines onto the paper. Next, place the shapes in another rectangle so that they overlap; trace the outlines. Finally, place the shapes in a random order of your choice and trace them.

Repeat the steps above in the remaining four rectangles. Try to have each of the new layouts look different from the first set of layouts.

40

Elements of Design: Shape

Exploring Negative Shape

- several pieces of 4-inch-by-4-inch oak tag or card stock

- cotton ball or tissue

- soft pencil, such as 6B

- scissors

Take a 4-inch-by-4-inch sheet of oak tag or card stock. Cut it into a geometric shape. Using a soft lead pencil, color heavily around all of the shape's edges. Place the colored shape on top of a piece of white drawing paper. Holding the shape firmly, use a cotton ball or tissue to rub from the center of the geometric shape outward, smearing the pencil onto the white drawing paper. Rub (from the center outward) around all edges of the shape.

Then pick up the shape, re-color its edges, and repeat the process elsewhere on the page. Experiment with creating overlapping shapes, shapes of different sizes, and organic shapes.

41

Exploring Positive and Negative Shape

- 4-inch-by-4-inch oak tag or card stock
- soft pencil, such as 6B
- scissors
- cotton ball or tissue

Take a 4-inch-by-4-inch piece of oak tag or card stock. Cut it into a geometric shape. Cut a smaller version of the shape out of the center. Using a soft lead pencil, color heavily around all of the shape's inner and outer edges. Place the shape on top of a piece of white drawing paper. Holding the shape firmly, use a cotton ball or tissue to smear pencil onto the white drawing paper both inward to the cut-out space and outward to the paper around the outer edges.

Pick up the shape. Look at how positive and negative shapes were created.

Now re-color the shape's edges and repeat the process elsewhere on the page.

Experiment with creating overlapping shapes, shapes of different sizes, and organic shapes.

42

Elements of Design: Shape

Scribble Deer

- drawing paper

- pencil or crayon

- drawing or photograph of a deer

In this exercise you will loosely draw a deer by simplifying its form into the most basic of shapes. Look at a realistic image of a deer. What general shape is the head? The ears? The neck? The body, legs, tail, and antlers?

Using a scribble line, draw a loose sketch of the deer. Do not concentrate on the contour or details of the animal. Instead, quickly scribble each of its body parts (one at a time) in crayon or pencil. Try to relax and let your eyes tell your hand what to do. You should be able to get a pretty good representation of its form using this technique.

43

© 2005 Walch Publishing

Floating Boxes

- drawing paper

- pencil

- ruler

Using the rules of two-point perspective, draw three-dimensional squares or rectangles. Draw at least three of them, and draw them so that they appear to be floating weightlessly in space. Draw at least one from a worm's-eye view, one from eye level, and one from a bird's-eye view. Think about how the forms might appear if slowly tumbled around in space. How could you place them on the page to indicate that movement in your drawing?

Daily Warm-Ups: Art

44

Finding Simple Shapes

- animal photographs
- tracing paper
- pencil

Choose a photograph of an animal. Look carefully at the photograph. Look for simple shapes within the animal, such as circles, ovals, rectangles and so forth. Point to them. Trace over them with your finger.

Place a piece of tracing paper over your animal photograph. Using a pencil, trace around the simple shapes that you found within the object. Trace only the shapes you see that make up the animal's general form; avoid tracing detail.

Daily Warm-Ups: Art

45

© 2005 Walch Publishing

Elements of Design: Form

Playing with Food

- potato
- toothpicks
- paring knife
- newspaper to cover work area
- damp paper towel for cleanup

Go ahead—play with your food! Pick up your potato. Look at its shape. Observe its texture and smell. Use your paring knife to randomly cut the potato. Using toothpicks, reassemble your potato into whatever shapes come to mind. Feel free to further cut and reassemble it into different creations.

Daily Warm-Ups: Art

Tube Design

- one or two empty paper-towel or toilet-tissue rolls

- scissors

- drawing paper

Cut your cardboard tube(s) into rings of equal thickness. Create a design by placing the rings next to one another on the drawing paper. Experiment with a variety of designs.

Next, try turning some of the rings into ellipses by pinching opposite edges. Try incorporating ellipses with the circles. What other designs can you come up with using these two shapes?

3-D Brainstorming

- small objects

- paper

- drawing materials

In brainstorming, there are no wrong answers. Go with the first idea that pops into your head and be open-minded to whatever ideas come next. If you have difficulty "thinking" of ideas, you are trying too hard. This should not be a cranial exercise. It should be more about spontaneity than thinking.

Daily Warm-Ups: Art

You have the next ten minutes to arrange the objects you have been given into as many different sculptural forms as possible. After each arrangement, do a quick sketch that captures the essence of the arrangement. Then move on to the next idea.

48

Odd Object Container

- oak tag
- pencil
- scissors
- ruler

Picture yourself as an industrial designer. You have been given the job of creating a shipping container for an oddly shaped object. Look at the object provided for this exercise. It is up to you to design a container that the object will fit into. Your container must have a lid or a hinged opening of some kind so that you can easily put the object in its container. The container must also keep the object safe while being shipped. You may use only the materials provided: oak tag, scissors, pencil, and a ruler.

49

Elements of Design: Form

Stick Figures Gain Weight

- drawing paper

- pencil, pen, or crayon

Draw a series of stick figures to show a person performing a simple task. For example, to show someone bending over to pick something up, the first stick figure would be standing, the next figure would be beginning to bend the knees and stretch out an arm, and so forth, until the last stick figure was bent over grasping the object.

Once your stick figures are complete, observe where you have drawn bends in the legs, arms, head, and neck. Do they make sense? If you are unsure, bend your arm or leg and see how it moves and where it bends. Make any necessary adjustments to your drawing.

Now, begin to color on top of the stick figures, fattening them up in the appropriate areas. Refer to your own body if you are unsure of where to make the stick figure thicker or thinner. Do not worry about details. Keep the figures in silhouette. Concentrate instead on getting each figure to look proportionally correct.

A Limiting Factor

- drawing paper

- pencil

Draw a human or animal form, limiting yourself to one type of shape. For example, create a robot using nothing but rectangles. Create a horse that is made up entirely of triangles. You may vary the size and orientation of the shape you use, but not the type of shape. Try to give the illusion of movement to your form.

Daily Warm-Ups: Art

51

Elements of Design: Form

Forms in Space

- pencil

- drawing paper

Imagine that you are a passenger in a spaceship way out in deep space. As you look out into the darkness beyond your window you notice geometric objects weightlessly floating by. Some of them are overlapping, some are at odd angles, some are very far away, others are almost touching the window. Using a pencil, draw what you imagine you see beyond your spaceship window.

Once your forms are drawn, add a light bulb to the drawing. Use this as the light source in your drawing. Shade in the geometric forms with this light source in mind. Remember: An object's darker side is farthest from the light source.

52

Elements of Design: Form

Found Object Sculpture

- found objects

- glue

Look at the found objects you have been given for this exercise. Spend two or three minutes arranging, balancing, and rearranging them in as many different ways as you can.

Choose one arrangement to glue together. If you can get the objects to balance or support one another, your structure will be more stable when glued. Gluing two rounded surfaces together, no matter how much glue you use, will not be sturdy; there is not enough surface-to-surface contact. Artists often create an illusion of this type of balance by finding ways to increase the surface contact (for example, by adding internal supports).

53

Slice and Wedge

- cardboard scraps

- scissors

In this activity you will create a freestanding form. Your form will be held together simply by cutting notches in your pieces so that you can hook them together.

For example, to create a freestanding triangle, cut two identical triangles. Cut a notch in the bottom center of one triangle, extending one half to three quarters of the way up the triangle. Cut a similar notch extending down from the top of the second triangle Holding the two triangles at right angles to each other, slide the first triangle down over the other, fitting the notches into each other. Your form can be as simple as a circle, or you can create something more complex, such as an animal or a person.

Daily Warm-Ups: Art

54

In The Year 2525

- drawing paper

- pencil

Imagine the year 2525. What do you think the neighborhood you live in now will look like then? Will solar panels and wind turbines be used to generate electricity? Will people be living underground? In outer space?

Draw your neighborhood or town as you imagine it will look in 2525.

55

The Space Between

- two contrasting colors of construction paper

- scissors

When creating a piece of artwork you shouldn't forget the negative spaces. They way you treat them is as important as the way you treat the positive spaces. To dramatize the importance of this concept, cut a large shape from colored paper. Choose a contrasting color to be used as a background. Cut your large shape in two pieces. (This does not necessarily mean cutting it in half using a straight line.) Lay the two pieces on the contrasting piece of paper as if they were one piece again. Now slowly slide the two pieces apart. Notice the various effects that you can achieve by the placement of the positive shapes and their related negative space.

Daily Warm-Ups: Art

56

Elements of Design: Space

Worms In Outer Space

- drawing paper

- pencil

Imagine a swarm of worms, floating aimlessly in space. Draw a single wormlike line on your paper. Determine how thick you want this particular worm to be; then complete the worm by drawing a second line that thickness away, parallel to the first one. Connect the ends of the two lines to create the worm's head and tail.

Now draw a second worm. Your second worm will cross under the first worm, forming a wiggly "X." Begin a wormlike line several inches away from the first worm. When the second wormlike line touches the first worm, stop. Imagine where this worm would appear on the opposite side of the first worm. Continue drawing from that spot. Decide on the new worm's thickness and draw a parallel line to form its body, head, and tail.

Continue to create overlapping worms floating in space until you have filled your paper. Experiment with varying the thicknesses and lengths of the worms.

57

The Illusion of Depth

- drawing paper

- pencil

Draw a horizon line high on your paper. Then draw the two sides of a pathway that begins toward the bottom of your paper and appears to wind its way back in space. The path will appear as if it is going back in space if it has a wider beginning, situated toward the bottom of your paper, and then narrows as it winds its way up the page, eventually coming to rest at your horizon line. Your path can climb at a steep angle much like a triangle until the tip of the triangle reaches your horizon line. Or it can zigzag its way back and forth across your page until it reaches your horizon line. Once your path is in place, draw whatever you like along the pathway. Keep in mind proportions: As things get farther away, they appear to get smaller, less defined, and lighter in value.

Daily Warm-Ups: Art

58

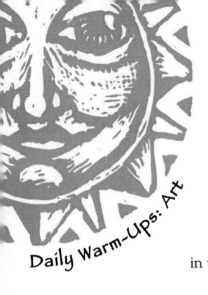

Hole in the Page

- scissors

- drawing paper

- colored pencils or marker

Cut a hole somewhere in your paper. On the back of your paper, write down five things you can think of that have a hole in them, such as a keyhole. Now, create a drawing that incorporates the hole in your paper.

59

Cityscape

- drawing paper

- pencil

For this exercise you will be creating a cityscape. Your paper can be placed in either portrait or landscape format. Begin by drawing a horizon line somewhere on your paper. On this line draw a series of tall rectangles, making sure to leave spaces between them. Feel free to vary the heights and widths of the rectangles and the spaces in between them. To show depth in your city, add some more rectangles that appear to be behind the others. Do this by starting a line at the center top of one of the rectangles. Then draw straight up, across, and come down on the center top of the next rectangle.

Think about what features you can add . . . heliports on tops of buildings, penthouse gardens, hotel signs. Have fun creating a city scene, adding taller and taller buildings as you see fit.

60

Daily Warm-Ups: Art

Elements of Design: Space

A New Perspective

- mug or paper cup
- drawing paper
- pencil

Look carefully at the mug or paper cup. Set it on the desk in front of you and do a simple contour line drawing. Now, look at your mug or paper cup from a bird's-eye view; from a worm's-eye view; from eye level. What other ways can you think of to tip or angle the cup to make it more interesting? Can you isolate and enlarge a small area of it rather than drawing the entire cup? When you are satisfied with an arrangement, do a contour line drawing from your chosen perspective.

61

© 2005 Walch Publishing

Imaginary Space

- drawing paper

- pencil

Sit up, plant your feet squarely on the floor, and close your eyes. Take a deep breath, hold it for a moment, then slowly exhale. Take five to ten more breaths, holding and slowly releasing each one. Try to focus your thoughts solely on your breathing. Now, begin to imagine a microscopic version of yourself, taking a journey inside your body. Use your mind's eye to explore your bloodstream, blood vessels, muscles, organs. Choose one area to focus on.

Now draw a picture of the area you focused on. Remember that your viewpoint is from a microscopic size, so the area you "explored" was comparatively large. Try to focus closely and re-create the details you "saw."

62

Rock Conquer

- pencil
- drawing paper
- rock

Choose a rock, viewing it as if it were a newly discovered land. Your task is to set up a new colony. Consider what land features you want to have: A high lookout to watch for possible enemy? Flat areas for farming?

At the bottom of the drawing paper, write your reasons for choosing that particular rock. Draw a picture of your newly colonized rock, complete with fort, villages, or other features of your colony.

63

Appearing Hand

- drawing paper

- pencil

Spread the fingers of your hand apart. Hold your hand over your drawing paper in order to see the contrast. Carefully observe the spaces between your fingers and the shapes created by the negative space. Now, looking at the negative spaces between your fingers, draw what you see. Concentrate on exactly reproducing the placement and size of the spaces.

Look at your finished drawing. What do you see?

64

Pattern Fill-in

- pencil
- black marker
- drawing paper

Choose five items that you see around the room. Draw a contour-line still life of the items you see. Arrange the items in a pleasing manner. Be conscious of how your still life fills the page. Don't draw your objects so small that they appear dwarfed by the surrounding page; draw them large enough that the paper's negative space creates an interesting shape.

Now, use a black marker to outline your still life objects. Fill each object in with a different pattern.

Daily Warm-Ups: Art

65

© 2005 Walch Publishing

Principles of Design: Pattern

Hair Lines

- drawing paper

- pencil or marker

You will team up with a classmate for this exercise. Have your partner sit with his or her back to you. Look carefully at your partner's head. Pay attention to details, such as how the hair is parted, or if the hair radiates out from an obvious crown point. Consider what type of repeated line you could use to show curly hair or braided hair. Will a thin line or a thick line work better?

Now, use a pencil or fine-point marker to draw the person's hair. After your drawing is finished, trade places with your partner.

66

Tessellations

- 2-inch-by-2-inch oak tag square
- scissors
- tape
- pencil
- 8-inch-by-8-inch drawing paper

On the left-hand edge of your oak tag square, draw an unusually shaped line. Start the line at the top corner and end it at the bottom corner of the left side of the square. Carefully cut along this line. Tape the cut-off piece to the right-hand side of the square, with the straight (uncut) edges matching. Be careful not to change the orientation of the taped-on piece; it should face in the same direction as its negative counterpart.

Use this piece as a tracing pattern. Create an interlocking pattern tessellation on your 8-inch-by-8-inch drawing paper. If you place your pattern carefully you should be able to get four repeats across the paper and four down, for a total of sixteen repeats.

Daily Warm-Ups: Art

67

Rug-Inspired Design

- scissors
- glue stick
- pencil
- construction paper
- reproductions of Navajo rugs

Look carefully at examples of Navajo rugs. List four characteristics that immediately stand out. Is the most stiking feature color? Shape? How do the elements you observed create a pattern? Is the pattern balanced or random?

Using construction paper, cut geometric shapes similar to those you observed in the rugs. Arrange the cut pieces on a contrasting color of paper. You may want to try several combinations before gluing the shapes down to your background color. Your final result should have the same characteristics that you observed in the rugs.

68

Daily Warm-Ups: Art

Allover Pattern

- colored pencils
- drawing paper
- still life

Choose one or two objects from the still life to draw. Draw the objects quickly without laboring over detail. Do not place the objects on the page according to their position in the still life, but place them randomly. Continue to add objects to your paper for five minutes.

After five minutes of drawing time, stop and look at your drawing. Is a pattern developing? Can you find areas of regular pattern? Is the pattern completely random?

Color in areas of your drawing to enhance the pattern quality.

Daily Warm-Ups: Art

69

© 2005 Walch Publishing

Printed Pattern

- two erasers
- 6-inch-by-9-inch drawing paper
- nonpermanent markers

You are going to use erasers to stamp a repeated pattern around the edges of your paper. Decide on two simple shapes or colors to use. Perhaps you want to stamp a light-colored solid area, then stamp a darker pattern over it? Whatever you decide on, keep it simple, for you will have to repeatedly re-ink the erasers.

Daily Warm-Ups: Art

Next, consider what type of repetition you will use. A pattern that repeats AB-AB-AB? AAB-AAB-AAB? BBA-BBA-BBA? Some other combination of your two shapes?

Using markers, draw a simple shape on the eraser or cover the entire edge of the eraser with solid color. Quickly, before the ink dries, stamp the eraser firmly near your paper's edge. Repeat the coloring and stamping steps until you have stamped a border around the edge of your paper.

Purple Ducks

- drawing paper
- markers, crayons, or colored pencils

Draw five simplified duck forms. They can be swimming, flying, standing—use your imagination. Use a purple marker or pencil to create a pattern inside each duck. Color in the rest of the picture with your choice of color, making sure that the purple ducks remain dominant.

71

Principles of Design: Pattern

Use Your Name

- ruler

- pencil

- drawing paper

With a ruler, divide your paper into eight equal parts so that it resembles graph paper. Lightly sketch one letter from your name inside each box. The letter should fill the box. Play around with order and orientation of the letters. You are using the letters as a design element only; they do not have to spell anything. You may use letters from your first name, last name, or initials to create your pattern.

72

Background Pattern

- drawing paper
- brayer
- inking surface
- low-relief textured or patterned items
- printing ink or tempera paint
- newspaper to cover work area

Place a textured item on top of the newspaper. Place your drawing paper on top of the item. Place some ink or paint on the inking surface. Roll the brayer in the ink or paint until it has a thin, even coating of color. Roll the brayer across the paper. The raised areas on the item under the paper will come through as the brayer rolls across, creating a patterned effect on the paper. If you care to, change items and roll again.

Daily Warm-Ups: Art

73

Crossword Puzzle Patterns

- crossword puzzle

- black marker

Look at your crossword puzzle. How can you use the spaces that are already blacked in to create an interesting pattern? Using a black marker, fill in other empty squares as you need to until you have created an interesting pattern. You may want to turn the paper sideways or even upside down so that you can see all the possibilities before you start. Turning your paper as you work can also be helpful. Sometimes a new perspective lets you see things in a new light.

Daily Warm-Ups: Art

74

Contrasting Materials

- glue
- magazines to cut up
- drawing paper
- colored pencils or markers

Cut out a magazine image that you like. It could be a person, an animal, a car, and so forth. Glue the image to your paper.

Now, develop a background around this image using colors or patterns that contrast with the image. Think in terms of opposites: smooth/bumpy, bright/dull, and so on. You can make a collage using pieces cut from magazines or use available drawing media. Be creative in your approach and choice of contrasts. Try to create a background that lets your magazine image remain the focal point of the picture.

Daily Warm-Ups: Art

75

© 2005 Walch Publishing

Intensity Exercise

- oil pastels
- drawing paper

Color can be like a chameleon. It looks different depending on its surroundings. A pure, intense color placed next to a neutral color keeps its intensity. This same color placed next to another intense color looks less intense.

Choose five oil pastels with intense colors. On your paper, put five two-inch squares of each color, each in a row by itself. Leave plenty of space around each square of color. Around the first square of color in each row, draw a heavy black border. Around the second, draw a heavy gray border. Surround the third color in each row with a heavy border of the color's complement. Surround the fourth square with a neutral color, created by mixing the color with its complement. Surround the last square in each row with a lighter value of the neutral, created by adding white to the color and its complement.

When you are finished, look at each row of color. Which center colors seem to have changed? Keep in mind that the only thing that is different is the border surrounding the squares of color.

76

As Plain as Black and White

- drawing paper
- burnishing tool or scissors
- soft pencil (6B)
- object to draw

Fold your paper in half. Using a soft lead pencil, draw an outline of the object you have been given on one half of the paper. Draw the object so that it fills the half page. Refold the paper with the drawing inside, pressed against the blank half of the paper. Rub the back of the drawing with a burnishing tool or the handles of a pair of scissors so that the drawing is transferred to the other half of the paper.

Color in the transferred object using a dark value. Color in the background of the original drawing using a similar value. Compare the two drawings. Record any visual differences. For example, does one object appear larger than the other? Why do you think that is?

Daily Warm-Ups: Art

77

Rock Strata

- crayons

- drawing paper

- photograph or example of sedimentary rock

Look at a photograph or an example of a sedimentary rock. Observe the textures, layers, and color variations. Use crayons to try to duplicate what you see.

Daily Warm-Ups: Art

78

Contrasting Shapes

- colored pencil or marker

- drawing paper

- pencil

Before you begin, brainstorm a list of ways in which contrast can be shown. For example, contrast can be shown by using complementary colors next to each other, light colors next to dark colors, bright areas next to dull areas, and so forth.

Fold the paper to create eight thumbnail spaces. Unfold the paper and draw one pair of shapes in each space, such as two circles, two triangles, two stars, and so forth.

Now, use colored pencils or markers to create contrast in each pair of shapes. Do not leave the inside of any shape uncolored. Try to use several different ways of creating contrast.

79

Surreal Interiors

- drawing paper
- markers or colored pencils
- reproduction of a Surrealist painting
- glue
- magazines to cut up
- scissors

Daily Warm-Ups: Art

What do you notice first about the Surrealist piece you are looking at? Do the images in the painting appear to be dreamlike? The Surrealists did not follow any particular rules. They were interested in the process of thought and in the unconscious mind.

Following no particular rule, create a colorful, patterned background on your paper. Onto this background, make a collage of images cut from magazines. Write a few sentences on the back about what drew you to choose the images, colors, and shapes you used. How do you think these choices affect the mood of the piece?

80

Principles of Design: Contrast

Monoprint

- water-soluble printing ink
- found objects and cardboard scraps
- burnishing tool
- brayer
- paper
- plastic sheeting

Place your paper under the piece of plastic sheeting. Be sure that the plastic is slightly larger than the paper. With a brayer, apply printing ink to the plastic. Do not let the ink go beyond the edges of the paper under the plastic.

Using found objects, draw into and remove areas of ink. The design will be strongest if it has contrast. Aim for a balance between inked areas and areas where the ink has been removed. You can hold the plastic up to the light to check for contrast.

When you are satisfied with the design, take the paper out from underneath and place it on top of the inked area. Using a burnishing tool, the back of a wooden spoon, or the heel of your hand, rub over the entire surface of the paper to transfer the ink from the plastic to the paper. When you are sure that every area has been rubbed, pull your print by lifting the paper from the plastic.

81

Color Contrast

- drawing paper

- markers

- pencil

Begin this exercise by drawing a square approximately 2 inches by 2 inches. Inside the square, draw another shape. Be careful not to make the second shape too small.

Now, choose one pair of complementary colors, such as blue and orange. Color in one of the shapes with the first color and the other one with its complement.

Redraw your two shapes. Color them in with the same pair of complementary colors, but in reverse order.

How do the complements look next to each other? Which combination do you like best? Why? Repeat your shapes, trying other complementary pairs.

82

Daily Warm-Ups: Art

Principles of Design: Contrast

Cast Shadows

- drawing paper

- dark blue or black crayon

- pencil

Have you ever thought about where your shadow falls at different times of the day? When you are outside in the early morning, where would a shadow be? How long would it be? What about at noontime? In the late afternoon?

Do a simple drawing of a person outdoors. Choose a time of day, and then draw the sun in the appropriate location in the sky. Think about where the person's shadow would be in relation to the sun. Draw the shadow on the opposite side of the person from the sun. If your sun is high in the sky, draw the shadow short. If your sun is low on the horizon, your shadow would be long.

83

Big, Bigger, Biggest

- colored paper
- scissors
- magazine to cut up
- glue

Choose three colors of paper to use as the foreground, middle ground, and background in a landscape. Remember that colors appear to get lighter as they get farther away. Place the background paper on your work surface. Tear the horizon line edge of the middle ground color and glue it in the appropriate location on the background. Next, tear the foreground piece. You may want to tear it to represent hills, trees, and so forth. Glue this piece down so that the middle ground is not hidden completely.

Cut images from magazines to fill your landscape. Keep proportions in mind. For example, if you cut out a tiny photograph of an SUV, place it in your landscape so that it looks proportionally correct. Once you have decided on the final placement of the images, glue them to the paper.

84

Principles of Design: Balance

Kaleidoscope Design

- ruler
- soft lead pencil (6B)
- drawing paper
- tracing paper
- burnishing tool

Draw a 9-inch-diameter circle on your drawing paper. Divide the circle evenly into eighths. In one section, create a simple symmetrical design. Lay tracing paper over the design and trace it with a soft lead pencil. Flip the tracing paper so that the pencil lines face downward, and lay it over the next segment of the circle. Use a burnishing tool to rub the back of the design so that the pencil transfers to the second segment. Re-trace the design, flip it, and rub it down in the next section. Repeat these steps until the design appears in all eight sections.

85

Paper Drop

- colored paper strips and shapes

- glue

- two sheets of drawing paper

- pencil or pen

Hold all your colored paper strips in one hand above one sheet of drawing paper. Drop them, and then glue them in place where they fall. Use the second sheet of drawing paper to repeat the process, only this time with your handful of shapes.

Daily Warm-Ups: Art

86

By dropping the paper, you created a completely random design. Is the balance of each design random? Is there a symmetrical, radial, or asymmetrical quality to either design? List any observations you make about the placement of the pieces on the page.

Principles of Design: Balance

Symmetrical Balance

- 6-inch-by-6-inch paper in primary colors

- glue

- scissors

Begin with three 6-inch-by-6-inch pieces of paper, one in each primary color. Leave one piece as a 6-inch square. Cut another diagonally into two triangles. From the third piece, cut a circle slightly smaller than one of the triangles. Use the 6-inch square as the background paper. Arrange the three smaller shapes on the background to create a balanced composition. Try several arrangements. When you have created the one you like best, glue it together.

87

Principles of Design: Balance

Asymmetrical Balance

- 6-inch-by-6-inch paper in secondary colors

- scissors

- glue

Begin with three pieces of 6-inch-by-6-inch paper, one in each secondary color. Leave one piece as a 6-inch square. Cut a large geometric shape from one of the other pieces. Cut an organic shape from the third piece of paper. Cut a smaller version of either the organic or geometric shape from the cut-off scrapes.

Use the 6-inch square as a background. Arrange the other three shapes on the background to create an asymmetrical design. Try several arrangements before gluing the pieces together.

88

Radial Design

- 4-inch-by-4-inch piece of graph paper

- fine-point markers

Find the center four squares on the graph paper by counting in from all four edges. Use a marker to outline these four boxes. This will become the center point in your design. Working from the center outward, one square at a time, create a radial design. (Remember, in a radial design, all the elements radiate from one central point.) In order for your design to have radial symmetry, whatever you do to one side of the design must be repeated on the other three sides.

The most effective designs are created when you avoid free-form shapes and curves. Limit yourself to designs created by filling in a square with solid color or pattern. You can cut a square in half diagonally (corner to corner), and then fill in or add pattern to some or all of its sections. Quartering a square (corner to corner like an X) and then filling in some or all of its sections with color or pattern is also effective.

89

Observing Balance

- drawing paper

- pencil

Look around the room. Where do you see balanced designs? You might see an example of radial balance in the way a student's hair is pulled up. You might notice symmetrical balance in the way the desks and chairs are arranged. Asymmetrical balance might be found in an uneven distribution of books on a bookshelf.

Record your observations by quickly sketching the design. Then label the drawing to say which type of balance you think it is. Quickly sketch and label as many examples as you can in the given amount of time for this exercise.

90

Principles of Design: Balance

Visual Balance

- assorted paper shapes
- pencil or pen
- drawing paper

Fold a sheet of drawing paper in half, open it, and draw a line down the fold. Imagine that each half of the drawing paper is one side of a scale. You are going to "weigh" combinations of shapes.

Place one or two paper shapes on each side of the paper. Look at the shapes, sizes, and colors. Does one combination of shapes appear heavier to you? On another sheet of paper, make a thumbnail sketch of what you see, and note which side looks heavier. Also note if the sides look balanced.

Reload each side with a new combination, and repeat the process. Record each combination, and take notes until your sheet of paper is full.

Possible combinations: one large shape vs. several small shapes, dark shapes vs. large light shapes, regular shapes vs. irregular shapes. Which do you find more interesting, the balanced or unbalanced groupings?

91

Rhythm Design

- cardboard scraps

- glue

- large piece of cardboard for background

There are five main types of rhythm: regular one-beat, alternating, progressive, flowing, and jazzy. Repeating a row of identical shapes is one way to show regular one-beat rhythm. Alternating rhythm could be shown by repeating two shapes of different sizes. Progressive rhythm could be shown by lining up a series of squares that gradually go from smallest to largest. A design that gracefully flows without any sudden changes has a flowing rhythm. Jazzy rhythm is exemplified by abrupt, sudden, and frequently changing repeats.

Choose one of the rhythmic styles. Cut some shapes from cardboard, and arrange them to show your chosen rhythm. Glue them down to a stiff piece of cardboard.

92

Principles of Design: Rhythm

Rhythm Practice

- scissors
- glue
- colored construction paper
- drawing paper

Draw four division lines horizontally across the drawing paper, creating five spaces. Cut out 25 identical shapes from colored construction paper. You may choose either geometric or organic shapes. You can cut a lot of shapes in a hurry by folding the paper several times, and then cutting through all of the layers.

In the first space on the drawing paper, arrange five colored shapes to show regular one-beat rhythm. In the second space, arrange another five shapes to create an example of alternating rhythm. In the third space, use five shapes (adjusting their size if necessary) to show progressive rhythm. In the fourth space, use five shapes to show flowing rhythm. In the last space, use five shapes to show jazzy rhythm. Be sure to label each example.

93

© 2005 Walch Publishing

Go with the Flow

- 3 1/2-inch floppy disk

- drawing paper

- pencil

Look closely at the details of a computer floppy disk. Imagine that the large rectangle is a doorway . . . where might it lead? Draw the disk with a path leading to the doorway. Draw things you imagine you might see along the path. Incorporate other disk details into your drawing if you like. See what your imagination comes up with.

Daily Warm-Ups: Art

94

All Stuck Up

- colored masking tape

- scissors

- drawing paper

Use pieces of colored masking tape to create a rhythmic design on the drawing paper. The tape can be cut or torn. Consider what colors might best represent the type of rhythm you have in mind. For example, which would best be suited to a jazzy rhythm, bright colors or dull colors?

Daily Warm-Ups: Art

95

Fingerprints

- 6B pencil

- drawing paper

Using a 6B or other soft lead pencil, color one finger on your nondominant hand until the lines in your finger are clearly visible. Draw an enlarged version of the lines you see on a piece of paper. The orientation can be either horizontal or vertical. What type of rhythm do you see? Is there a natural flow to the design that is appearing in your drawing? What similarities are there between your drawing and someone else's drawing?

When you have finished drawing your enlarged fingerprint, stamp a real fingerprint at the bottom of the page.

96

Daily Warm-Ups: Art

Rhythm Through Line

- tempera paint
- palette or tray
- cardboard scraps
- drawing paper

Slowly say your name (first name and last name) to yourself, counting out the syllables. Use the number of syllables in your name to stamp out a rhythmic line design. Spread tempera paint on a palette or tray. Dip the edge of a piece of cardboard into the paint, use the cardboard to stamp your name's rhythm on the paper. Can you create more than one type of rhythm by quickly saying/stamping your name several times in a row? By saying/stamping your name very slowly? Experiment with a variety of rhythms using groupings of lines based on your name's syllables.

Daily Warm-Ups: Art

97

© 2005 Walch Publishing

Circles

- drawing paper

- pencil

List five round objects that can be drawn in a way that shows movement. Examples might include a basketball being bounced, or pizza dough being tossed in the air.

When you have listed five objects, make a simple drawing of each one. Add motion lines to show the indicated movement.

Daily Warm-Ups: Art

98

Straw Rhythm

- paper drinking straws

- railroad board or other type of cardboard

- scissors

- glue stick

Daily Warm-Ups: Art

Use your handful of straws to create a design. You might try arranging them so that they are lying down. Or try standing them on end, cutting each straw to a different height. Create a design that shows one of the following types of rhythm: regular one-beat rhythm, alternating rhythm, progressive rhythm, flowing rhythm, or jazzy rhythm. When you have a rhythm you like, glue the straws in place.

99

© 2005 Walch Publishing

Recorded Movement

- magazines

- pencil or pen

- notebook paper

Movement in art takes many forms. Compositional movement is created by the artist to lead your eye through a painting, much as a road map helps lead you through an unknown area. Actual movement can be experienced in theater, music, sports, kinetic art, and so forth. Recorded movement is visually implied. Consider sport photographs, paintings of horse races, and drawings of dancers. Our brain knows what would happen next in real life even though the image is still, not moving.

Look carefully at the photographs in your magazine. Write as many different examples of movement as you can you find. Which examples do you find most interesting? Why?

100

Recorded Action Lines

- pie tin
- marble
- tempera paint
- drawing paper
- scissors

Put a small amount of paint along one edge of a pie tin. Cut the paper to fit inside the tin and place it in the tin. Drop a marble in the paint. Hold the tin, tilting it slowly back and forth so that the marble rolls across the paper, recording its path with paint. Experiment with the angle and direction of tilt. What is the visual effect of your experimentation?

Daily Warm-Ups: Art

101

Free-Flowing Ink

- newsprint

- soft brush

- newspaper to cover work area

- container of ink

Use newsprint or other soft paper for this warm-up. Hold the brush
vertically. Dip the tip into the ink and create a free-flowing stroke in one
area of the paper. Reload the brush with ink. This time try pushing down and
then lifting up on your moving brush to achieve a free-flowing stroke of
varying thickness. Try making marks by splitting the hairs on your brush.
Experiment with strokes to make as many different free-flowing marks on your
paper as you can.

Everyday Pattern

- pencil
- drawing paper
- markers

Look around the room for examples of pattern. Locate five different patterns. Look closely at their repetition. Combine these patterns to create a new repetitive design. Design a drawing that will get a viewer's eye to follow a particular path. This movement can be controlled not only by your choice of pattern but also by the size, color, texture, and placement of the pattern on the page.

Daily Warm-Ups: Art

103

Principles of Design: Movement

Down to the Last Straw

- oak tag
- tape
- scissors
- paper or plastic drinking straws

Begin by cutting four small squares, all the same size, from each corner of a piece of oak tag. Next, fold up the four sides, creating something like a shallow box. Tape the edges in place. Half-fill this box with straws placed on end. Use scissors to snip the straws to various lengths, and then place the snipped-off pieces in the box. Eventually the entire box will be full of straws. Arrange the pieces of straws in such a way that you create a look of movement across their surface.

104

Rope-Making

- yarn

- unsharpened pencils

- scissors

Measure and cut four pieces of yarn about 6 feet long. Hold the yarn pieces together in your hand. Then, knot together the pieces of yarn at both ends. Stand facing your partner. Insert one unsharpened pencil through each knot. You and your partner need to back away from each other until the yarn between you is taut. Each of you should hold up one hand, palm out. Place the pencil and the yarn knot between your index and middle fingers. Keeping the yarn taut at all times, one person should turn the pencil as if it were the hands on a clock. The second person should to turn the pencil in the opposite direction.

When the yarn is full of over-spin (twists on itself if allowed to go slack), stop spinning. Keeping the rope taut, hand both pencils to one person. The second person should find the center of the rope. Then, inch by inch, let the rope twist up on itself, creating a shorter length of twisted rope.

Daily Warm-Ups: Art

105

© 2005 Walch Publishing

Flip Books

- index cards

- pencil, pen, or marker

Draw a sequence of drawings that record some type of action, one frame at a time. Keep your drawings simple. For example, you might try drawing someone bouncing a ball, jumping rope, or kicking a ball. Create your drawings along the outer edge of index cards, one drawing per card. Be sure that each drawing has the same orientation.

When the drawings are complete, hold the stack of cards in one hand and flip the cards with the other hand. See how well your drawings show movement. If necessary, make adjustments to your drawings.

Daily Warm-Ups: Art

106

Principles of Design: Movement

Star Trace

- 9-inch-by-12-inch drawing paper
- pencil
- free-standing or propped-up mirror
- dark-colored construction paper

Draw a large five-pointed star on your drawing paper. Using parallel lines, draw a second five-pointed star inside the first, leaving about 1/2 inch between the stars.

Next, hold a sheet of construction paper above the drawing paper so that you cannot see the star. Place the mirror along the top edge of the white paper. Adjust the paper and mirror so that you can see the star in the mirror only. Put your hand under the construction paper. Use a pencil to trace between the two lines of the star, looking at what you are doing in the mirror only.

Were you able to complete the task? Did any corner give you difficulty?

107

Principles of Design: Movement

Motion Lines

- drawing paper

- pencil or pen

Motion is indicated in cartoons by the use of motion lines. An example might be a hopping rabbit followed by a series of curved, dashed lines to show where the rabbit had been hopping, and how high the hops had been.

Draw a cartoon character of your own. The character should be engaged in some type of activity, such as hopping. Place motion lines wherever they are needed to indicate movement.

Daily Warm-Ups: Art

108

Logo Design

- drawing paper
- pencil
- marker or colored pencil

Use your name or initials to create a logo for yourself. The logo should say something about you or what you like. If you play sports, how might your logo represent the sport you play? If you enjoy a certain style of music, how might you use your name or initials to represent that music?

After you have designed the logo, add color. Choose colors that are eye-catching and that say something about you.

109

© 2005 Walch Publishing

Principles of Design: Emphasis

Place the Emphasis On . . .

- drawing paper

- pencil

- colored pencils, markers, or other colored media

Use a pencil to write the word EMPHASIS so that it fills the paper. Write the letters as block outlines, with plenty of white space inside the outlines.

Now, choose part of the word to emphasize. It could be one or more letters. It could be part of a letter. How will you emphasize this part? Will you use color, pattern, tone, or a combination of techniques?

Finally, use pencils or markers to color in the whole word. Make sure the emphasis remains on the area you chose.

Daily Warm-Ups: Art

110

Horizon Lines

- drawing paper

- pencil

You're going to experiment to see how changing the horizon line can create a very different feeling in a landscape. Fold your paper vertically to form three equal parts. In one section, draw a horizon line about one-third of the way down from the top of the section. What type of effect do you think this high horizon line would have on a finished landscape? In the next section, draw a horizon line in the middle of the section. Again, try to imagine how a horizon line that shows the same amount of land and sky would affect the final drawing. In the last section, draw a horizon line low in the section.

Which horizon line choice do you think would give the calmest feeling to a landscape? Which one do you think would have a more dramatic effect?

111

© 2005 Walch Publishing

Principles of Design: Emphasis

Action Snapshots

- pencil

- drawing paper

Think of places or situations where people are physically moving, such as at a sports event or in a theater. Think about how and where the human body bends in each situation. Fill your drawing paper with stick figures, each showing obvious signs of physical movement. Arrange the figures on your paper like snapshots in a photo album. Don't get hung up on details; focus on showing action.

Once your stick figures are complete, observe where you have drawn bends in the legs, arms, head, and neck. Do they make sense? If you are unsure, bend your arm or leg and observe how it moves, where it bends. Make any necessary changes to your action snapshots.

112

© 2005 Walch Publishing

Metamorphosis

- pencil
- drawing paper

Begin by dividing your paper into four equal thumbnails. Next, draw one form of your choice (cone, cube, and so forth) in the first thumbnail space. Look at the form you've drawn. Imagine that there is something inside the form. There is no way for the "thing" to get out except by pushing its way out of the shape. For example, imagine what it would look like if a turtle pushed its way out of a cube.

Do three more drawings (one inside each thumbnail) of your form with the "thing" trying to push its way out. Each drawing should emphasize the look of the "thing" pushing out. Your original form will become less and less distinct. By the last thumbnail, your "thing" will have completely undergone metamorphosis, taking the the place of the original form that you drew.

113

Mirror-Image Name Design

- scissors
- drawing paper
- colored paper
- drawing paper
- broad-point marker

Using a broad-point marker, write your name in cursive in the bottom half of the colored paper. The letters should be at least 1 1/2 inches high. Fold the paper in half so that the top edge of your name is on the fold line of the paper, with the writing side out. Keeping the paper folded, carefully cut out your name, through both layers of paper, so that it remains intact.

Unfold your cutout name and glue it (marker side down) onto a piece of drawing paper. Create a line design around the name. The mirror-image names should remain the focal point. The line design should continue until it reaches the outer edges of your paper.

Daily Warm-Ups: Art

114

Principles of Design: Emphasis

Botanical Names

- drawing paper
- markers or colored pencils
- pencil
- container of flower names

Without looking, reach into the container and choose one of the flower names inside. Each name in the container is an actual name of a plant or flower. Draw your interpretation of the plant based on nothing but its name. Think about how the plant will break up the paper in the most interesting way. Avoid drawing a small plant in the middle. For example, you might arrange your drawing to emphasize an aspect of the plant's name, such as a drawing of a lady's slipper at the base of a bed or shown with a dressing gown. Humorous interpretation is definitely acceptable here. Be sure to add detail to the drawing, such as vein lines, variety and value in colors, and so forth.

115

Doodle Drawing

- drawing paper

- pencil

Scribble without thinking on your paper. Now turn your paper
90 degrees. Does an image appear to you? Again, turn your paper
90 degrees. Any image? Keep turning your paper until you see an image
(or images), and then work into the scribble to make the image stand out.
You can add details to enhance an image, color sections in, and so forth.
Additional lines and shapes may be added to enhance the found image.

If you are stuck and no image appears to you, trade your paper with someone else.
Try to find an image in the new scribble.

116

Building a Mystery

- pencil

- drawing paper

- still life objects

On a single sheet of paper, draw the objects provided for you. Once you have drawn the last object take a moment to study your drawing. Does one area or object dominate the composition? Beginning with the dominant object or focal point of the drawing, create a mystery story that centers on the objects you drew. Write the story on the back or bottom of your paper.

Daily Warm-Ups: Art

117

© 2005 Walch Publishing

Watercolor Repetition

- watercolor pencils or watercolor markers

- paper
- newspaper to cover work area

- brush water
- paper towel or sponge for blotting

- assorted stencils

Choose one stencil that appeals to you. Choose watercolor markers or pencils in either cool or warm colors. Trace around the inside edges of your stencil, lifting and repeating to create a design. You do not always have to trace using a single color. Try variations in color to add to the overall effect.

Once you have created an appealing design, brush over each of the stenciled areas with water. Try brushing an area using strokes that all go in the same direction. Then try brushing an area using strokes that go in random directions. How does changing the stroke affect your design? Can the brush stroke variations become part of your design?

Daily Warm-Ups: Art

118

Organizing Odd Shapes

- magazines to cut up
- scissors
- glue
- paper
- pencil or pen

This exercise calls for taking odd, unrelated shapes and organizing them in such a way that they appear unified. From a magazine, cut out ten shapes that interest you. Be sure each shape comes from a different page so that they are not related in any way.

Now, arrange the shapes on your paper. Organize them by what they have in common. Is there a common color, texture, or size? Try to place the shapes on the paper in a pleasing and unified way. When you are satisfied with the arrangement, glue the shapes in place.

Write a sentence or two explaining your reasons for placing the pieces the way you did. What do you feel has unified them?

119

© 2005 Walch Publishing

Principles of Design: Unity

Literally Speaking

- paper
- pencil
- newspaper headlines
- scissors
- glue

Look through the newspaper headlines. Find a headline that can be interpreted literally and would make for a silly or unique artistic composition. For example, you could use a headline in the sports section that read "Star Player leaves Gators," or one that read, "College takes on respiratory therapy." Create a drawing for the headline you found. Literal translations of headlines can often be interpreted in humorous ways. Incorporate the actual headline into your artwork as if it were a caption.

Daily Warm-Ups: Art

120

Principles of Design: Unity

A Joint Effort

- drawing paper
- pencil

Begin by drawing a simple line or shape. Pass the sheet of paper to the person next to you. Your neighbor should now draw a simple line or shape on the paper and pass it back to you. Continue in this back-and-forth fashion until you have a finished drawing.

121

Changing Surface Quality

- large newspaper photograph
- eraser
- paper
- pencil
- markers

Choose a large black-and-white or color photograph from a newspaper. On a sheet of paper, write the qualities that you feel give unity to the photograph.

With a pencil eraser, change the qualities you listed by partially or entirely erasing them. You will have to bear down fairly hard on the eraser—be careful not to tear the photograph! On your paper, note the visual effect erasing had on the unity of the photograph.

Now, using markers, draw into the erased areas. You might add a drawn version of what used to be there, or add something entirely new. Write down the effect that drawing into the photograph had on the image.

Daily Warm-Ups: Art

122

Principles of Design: Unity

Masking Tape Resist

- masking tape
- drawing or watercolor paper
- newspaper to cover work area
- paper towel or sponge for blotting

- watercolors
- fine-point marker
- water
- brush

Stick pieces of torn or cut masking tape to a sheet of drawing or watercolor paper. Arrange them so that there is a nice balance between the tape and the negative space around the tape. You can place the tape in either an organized or a haphazard way.

When ready, use watercolor to paint over the surface of the paper and tape. When the entire paper has been colored and is dry, remove the tape. What was positive has now become negative and color unifies the entire piece.

123

Change Can Be Good

- notebook, printer, or drawing paper

- scissors

- pencil

How many times in the day do you see a flat, blank sheet of paper? Take a blank sheet of paper and, without drawing on it, change the way it looks. Perhaps you could try cutting windows in it. Leave the windows open or shut, curl them or fold them for added interest. Perhaps you'd rather cut the paper into pieces and reattach it using slots and joints. Try scoring and bending the paper. When you have finished, write one or two sentences explaining what gives your finished piece unity.

124

Daily Warm-Ups: Art

Materials and Techniques

Solution Versus Saturation

- nonpermanent black marker
- 1-inch circular template or playing piece
- paper cup or other container
- water

- coffee filter
- scissors
- paper plate

Cut a circle from the coffee filter. Fold the circle in half, and then in half again, to find the center of the circle. Unfold the circle.

Place a circular template in the center of the circle. Trace around it with a black marker. Go over the line, adding to it until it is about 1/4-inch thick. Refold the circle in half and in half again to make a wedge shape.

Pour just enough water into the cup to cover the bottom. Put the folded coffee filter into the cup so the point of the wedge is in the water. Wait about 15 seconds. Take the coffee filter out, unfold it, and put it on a paper plate so that the creases you made face up.

Watch the filter paper for about five minutes. What happens to the black marker? Can you explain what you see?

125

Look Closely

- paper

- magnifying glass

- pencil or pen

Paper. You write on it, draw on it, run it through the printer and copy machine. You use it in hundreds of ways—but have you ever examined it closely?

Until 1866, most paper was made from cloth rags. Then an American chemist named Benjamin Tilghman found a way to soften wood and break down the tough fibers. Today, most paper is made from wood, processed in water. To make one ton of paper, one hundred tons of water is needed!

Tear a corner from a sheet of paper. Look at it under magnification. Do you see tiny little hairs? These hairs are cellulose fiber. The fibers are the reason wood can be used to make paper. They are long enough to cross over each other and make a web of fibers. When this web dries, it forms a strong sheet.

Besides writing and drawing, paper has many other uses. List at least ten other ways paper can be used.

126

Daily Warm-Ups: Art

Book Making

- paper
- drawing and coloring supplies
- glue (optional)

Before the invention of the printing press, books were handmade by skilled artists. Only the wealthiest people could afford to own one. Some of the earliest books were made in China as early as 2200 B.C.E.

Here is one early technique used to make books in ancient China. Fold a sheet of paper in half lengthwise. Next, fold it in half crosswise. The folded piece should be about 5 inches high and 4 inches wide. Fold it in half crosswise again. It should now be about 3 inches wide and 4 inches high.

Unfold the last two folds until you have a long, narrow piece that is two thicknesses of paper. Refold along the creases so that one fold goes forward and the next one goes back, as if you were making a paper fan. This is the basic book shape.

Use pencils or markers to draw on the pages of your book. If you prefer, you may want to glue shapes on the pages, or draw borders around them.

127

Daily Warm-Ups: Art

One Square at a Time

- magazine photographs
- white paper
- ruler
- scissors
- pencil

Choose a magazine photograph. Use a ruler and a pencil to draw a grid over the photograph. The size of your grid will depend on the size of your photograph. One-inch squares often works well. When you finish, your photograph should be divided into equal squares.

Choose one square of the photograph to reproduce. Try to choose a square with simple shapes. A square with lots of fine detail will be harder to reproduce.

On a sheet of white paper, draw a square the same size as the squares of your grid. Inside this square, copy the section of the photograph. Look carefully at the lines and angles within the square. Copy them as carefully as you can.

When you have finished drawing, cut out the square you drew. Place it over the matching square on the photograph. Do the lines you drew match up with the lines of the original photograph?

128

Materials and Techniques

Trompe l'Oeil

- magazine photographs

- drawing materials

- drawing paper

Trompe l'oeil means "trick the eye." Skilled artists who enjoy visual tricks sometimes create paintings that fool the eye. They may paint wood to look like marble, or paint what looks like a slightly opened door on a wall, complete with stairs behind the door and clutter on the steps. Cornelius Norbertus Gijsbrechts painted what looks like the back of a canvas. It is so realistic you want to turn it around to see what is painted on the other side. Adirondack artist Tim Fortune painted a series of cubbyholes on a wall in a local art center, complete with a crumpled candy-bar wrapper.

Try your hand at trompe l'oeil. Choose a photograph from a magazine. Add some small, carefully drawn detail to the photograph. You might add a bug on someone's nose, or a crack in some object. Share your result with a partner. See if your partner can pick out what you have added.

129

© 2005 Walch Publishing

Still Life

- objects for a still-life drawing
- ruler
- paper
- drawing materials

For centuries, artists have painted inanimate objects. The French masters called this *nature morte*, or "dead nature." The Dutch called it "silent life." In English, we call it "still life."

The objects in a still life may look haphazard. However, choosing and arranging the elements calls for a lot of care and thought.

130

Arrange several objects that appeal to you. Draw them using contour line. To decide where the tabletop should appear in your drawing, place a ruler horizontally across your drawn objects. See how that placement would look. Now slide the ruler up and down the paper until you find the most interesting placement for your tabletop. Draw a horizontal line for the tabletop.

Next, break up the background space behind your still life. Draw one vertical line to suggest the corner of a wall. Draw part of a rectangle to suggest a window.

Once your background space is broken up, add color to one of the two walls. Then color in the objects so that they stand out from the background.

Horizon Lines

- three sheets of drawing paper
- pencil

You're going to draw a simple landscape. Before you begin, you need a horizon line.

On the first sheet of paper, lightly draw a pencil line across the page, about one-third of the way down from the top. (It's important to make the line very light so that you can erase or cover it later.) This will give you a high horizon line.

On the next sheet of paper, draw a line about half-way down the page. This will give you an eye-level horizon line.

On the third sheet of paper, draw a line about one-third of the way up from the bottom of the page. This will give you a low horizon line.

Sketch a similar landscape on each page, using the line you drew as the horizon.

Did the height of the horizon line affect the finished work? Write one or two sentences describing how changing the horizon affected the drawing as a whole.

Daily Warm-Ups: Art

131

Postcard Time Line

- five to ten art postcards or small reproductions

- paper

- pencil or pen

Take five to ten art postcards or small reproductions. Which one do you think was painted first? Which do think was painted last? Arrange them in a time line from left to right, starting with the painting you think was painted earliest. Then write an explanation of the criteria you used to decide which came first.

Daily Warm-Ups: Art

132

November 18, 1879

- reproductions of cave paintings
- paper
- pencil or pen

On November 18, 1879, a nine-year-old girl in Altamira, in northern Spain, stumbled on some extraordinary cave paintings. They were probably painted about 15,000 years ago. The unknown artists used natural pigments such as ochre and charcoal to paint amazingly lifelike animals.

Look at some examples of cave art. Which elements of design are most evident? Which principles of design?

These paintings were created before people started keeping written records. Therefore scientists can only guess how and why they were made. Why do you think early humans created cave paintings? List as many reasons as you can.

These paintings were created deep within caves, away from any sources of natural light. They were often painted on the cave ceilings. Many of the animals are painted life-size. Keeping all this in mind, draw five tools that an early artist might have used to create these paintings.

Daily Warm-Ups: Art

133

Contour Cave Images

- reproductions of cave paintings
- photographs of animals
- colored pencils or markers
- pencil
- drawing paper

Look carefully at some cave paintings of animals. Notice that the emphasis of the paintings is on describing the subject, not showing what the artist actually saw. For example, a bull drawn in profile will often show both horns. See how cave artists used color to emphasize an animal's form and muscle tone.

Now, choose an animal photograph and create a contour line drawing of the animal. Using line, draw your animal as descriptively as possible. At the same time, keep your drawing simple. Fill your page with complete or partial images. If time allows, add neutral color to one or more of your drawn animals. Again, base your coloring on the cave artists' approach.

134

Art Appreciation

Prehistoric Figures

- reproductions of cave paintings of animals and of people

- pencil or pen

- paper

A *pictograph* is an ancient painting on a rock wall. Compare images of animal pictographs to people pictographs.

How are they similar? How are they different? Judging from the realistic representations of animals, it appears that cave artists had the skill to depict people realistically. Why do you think they did not? Write one or two sentences for your answer.

135

The Tigris and Euphrates Rivers

- map of Southwest Asia

- reproductions showing Assyrian and Persian bas-reliefs

- drawing paper

- pencil

Find the Tigris and Euphrates rivers on a map. What countries do these rivers pass through? Over the centuries, this area has been the center of many civilizations. The Assyrian Empire flourished here around 900 B.C.E. By 300 B.C.E., the Persian Empire ruled.

Daily Warm-Ups: Art

136

Look at examples of relief sculptures created during the Assyrian and Persian empires. What is the most common subject matter? What techniques did the artists use to support the subject matter?

Imagine that you are an artist, living in an ancient empire. The current ruler of your country has asked you to create a bas-relief sculpture that will show all the ruler's strengths. On a piece of paper, design a bas-relief for your ruler. Try to use a drawing style that emphasizes the ruler's strengths and mimics the style of the ancient artists of this area.

Ancient Extreme Sports

- reproductions of Minoan frescoes
- drawing paper
- pencil
- colored pencils or markers

Fragments of a fresco have been found in the palace of Knossos, the center of the ancient Minoan civilization. The fresco dates to about 1500 B.C.E. It shows a scene that suggests today's extreme sports, or x-games. A young man somersaults over the back of a galloping bull. One young woman grasps the horns of the same bull; another young woman appears to have just landed after a somersault over the beast's back.

There is nothing static about this mural. The artist uses curved lines to emphasize the action. The viewer can easily imagine what happens next.

Look at examples of how men and woman were shown in the frescoes of the late Minoan period. They are shown with neatly curled and styled hair, and heavily outlined eyes. Careful attention was paid to clothing details. Distinct colors were used to represent men and women. Both men and women had tiny, pinched waists.

Choose a modern-day extreme sport. Draw it using the characteristics described above so that it resembles a fresco from the late Minoan period.

137

© 2005 Walch Publishing

Life After Death

- reproductions of ancient Egyptian portraits

- drawing paper

- pencil

Daily Warm-Ups: Art

People in ancient Egypt believed in life after death. To be certain they had everything they would need in the afterlife, people were buried with paintings or models of their favorite possessions.

Egyptian belief in an afterlife was one reason for their stylized artwork. Egyptian drawings used a twisted perspective so that every part of the body is seen. A person's life in the afterworld depended on the way the person appeared in tomb paintings. If a man's portrait only showed one arm, he might have only one arm in the afterlife. When artists today draw a person walking, they show only the arm and leg that face the artist. The viewer's mind fills in the blank; we assume that there is another arm and another leg on the other side of the body. The Egyptians did not leave it up to chance; they drew both arms.

Use twisted perspective to draw a picture of yourself and your most valued possessions. Draw every important detail so that it can be easily seen in the afterlife.

138

Art Appreciation

"Know Thyself"

- reproductions of Greek statues

- drawing paper

- pencil

Many ideas that people still hold today were first developed in ancient Greece. For example, the Greeks believed that becoming well educated was a step toward self-knowledge. They believed that knowing your physical limits was another way of knowing yourself. The original Olympic games began in Greece. Greek art depicts the ideal, physically fit human body.

Think about activities you enjoy, both in school and outside school. Draw yourself engaged in an activity that will show a side of yourself others may not know—something you know about yourself and would like to share with others. Your portrait should be idealistic, not necessarily realistic. You can give yourself perfect hair, each curl neatly in place, perfect muscle tone, and so forth.

139

Fabulous Fibula

- photographs of fibulas
- pencil
- drawing paper
- colored pencils, markers, or paint

The early Greeks and Romans didn't have buttons, snaps, and zippers. How did they hold their clothes together? They often used a pin called a *fibula*, which is like an early safety pin. It usually consisted of a straight pin that was coiled to form a spring. The metal was then curved back over on itself to form a bow and a catch-plate to fasten the pin. (Think of a capital letter "D." The pin back was like the straight part of the "D." The bow was like the curved part.)

140

Early fibulas were very simple in design, but later pins were heavily ornamented. The metal bow of the pin was made wider and thicker. Some pins were covered with swirls, interlacing lines, and other geometric designs. In some, tiny rows of animals were attached to the bow of the pin. In others, the bow itself was made in the shape of an animal. Some pins were decorated with colored enamel or precious stones.

Design a fibula. Start with a geometric shape. Fill it with a design that emphasizes your chosen shape. Complete your design, then fill it in using jewel-like and metallic colors.

Daily Warm-Ups: Art

Chinese Painting

- ink
- water
- bamboo brush
- mixing cups or other small containers
- newsprint or rice paper

Paper was invented in China about 2,000 years ago. Artists soon started using the new material for paintings.

Chinese painting is viewed as a form of lifelong meditation. At first glance, the work seems easy to do. However, learning to capture just the essence of your subject is not so easy. It is said that in order to paint bamboo you must have a bamboo inside. Knowing your subject matter so thoroughly that you can paint it without looking at it calls for quiet, contemplative observation. It also calls for a complete understanding of your materials.

Create several different values of ink by mixing ink and water in a few small containers. Dip your brush into one ink value. Sweep it across a sheet of newsprint. What does the brushstroke look like?

Vary your strokes and ink values to create different effects on the paper. Try layering strokes over each other. Make as many different types of marks as you can.

Daily Warm-Ups: Art

141

Mosaics

- reproductions of Byzantine mosaics
- colored paper, cut or torn into small tile shapes
- paper for background
- glue stick

Early Christian and Byzantine mosaics were created for the church. Artists used small tiles to create images, often larger than life-size, on the walls and ceilings of churches.

Daily Warm-Ups: Art

Look at some examples of early mosaic art. Note how the artists change direction and color to help them to achieve folds in cloth, wool on sheep, and so forth.

Choose an item of clothing that you are wearing. Observe it closely. Pay attention to subtle color changes due to folds in the cloth or shadows.

Use small pieces of colored paper to re-create the item in a mosaic. Choose colors that will let you show the changes in color you observed in the item. Glue the squares to the paper, leaving a small white space around each square.

142

Illuminated Manuscripts

- reproductions of illuminated manuscripts

- drawing paper

- drawing materials

During the medieval period in Europe, all books were made by hand. Artists used their skills to decorate books, making them as beautiful as possible. They used bright colors with gold and silver highlights. Letters that began important passages were given special attention. These letters were often drawn larger than the rest of the text. Some included pictures of fantastic animals, flowers, even people. Fine examples of the art of illuminated manuscripts include the Book of Kells (finished around 800 C.E.), Moralia in Job (around 1100 C.E.), and the Gospel Book of Otto III (around 1000 C.E.).

On your drawing paper, draw the first letter of your name as large as possible. Use a box letter or a bubble letter so that you can decorate it in the style of an illuminated manuscript. Be sure to make the letter thick enough so that not only can you decorate around the letter, you can also decorate within it.

Daily Warm-Ups: Art

143

Art Appreciation

Andrea Mantegna

- reproductions of paintings by Andrea Mantegna

- drawing paper

- pencil

Look at reproductions of some of Andrea Mantegna's paintings. This Italian Renaissance painter took great pleasure in creating works of art from unusual angles. The strength created in his paintings by changing the viewer's perspective makes him stand out as a master painter.

Use an unusual angle to make a drawing of your own. You might try a foreshortened drawing of your finger pointing at you. You might place an object on your desk and draw it from eye-level or looking up from below. Add dramatic lighting and shadows for additional effect.

144

Albrecht Dürer

- reproductions of drawings or etchings by Albrecht Dürer

- drawing paper

- pencil

- small object to draw

The fine detail of this artist's work, whether the subject is realistic or imaginary, is inspiring. Whether his medium was watercolor or woodblock, painting or etching, Dürer paid attention to every little detail.

Choose an object to draw up close. See how many details you can reproduce. Pay attention to the object's shape, value, and texture. Place your drawing on the paper so that it breaks the space up in a way that adds interest to the overall composition.

145

Michelangelo

- reproductions of works by Michelangelo Buonarroti

- drawing paper

- tape

- pencil or marker

Daily Warm-Ups: Art

If ever there was a Renaissance man, surely it was Michelangelo. He was an architect, sculptor, and painter of the highest degree. Among his achievements is the fresco on the ceiling of the Sistine Chapel. He single-handedly painted the 5,800 square feet of this vaulted ceiling. For four years he lay on his back almost 70 feet above the floor, working out the problems of perspective as the painting would appear from the floor while creating dramatic biblical scenes.

Tape a piece of paper to the underside of your desk. Climb under your desk and lie on your back, facing up. Spend the next ten minutes drawing on the paper overhead. What do you think it felt like to work in that position for four years?

146

Arcimboldo Portraits

- reproductions of Giuseppe Arcimboldo's portraits using objects

- drawing paper

- pencil

Look carefully at the portraits painted by Italian painter Giuseppe Arcimboldo. Can you see how he might have come up with his portrait ideas?

Now, think about some objects that you like or that you often use. Imagine how you could use these objects in a self-portrait that would say something about your interests. Sketch the outline of a face on a sheet of paper. Try using your favorite objects to create eyes, a nose, and a mouth on the face.

147

Rembrandt's Etchings

- reproductions of Rembrandt etchings
- nail or other pointed object
- water-soluble printing ink
- piece of Plexiglas
- paper towel or rag
- damp drawing paper

In his etchings, Rembrandt paid amazing attention to detail. Many of his etchings were tiny—only an inch or two square. But they were filled with so much detail that you need a magnifying glass to see it all.

Create your own etching using Plexiglas. Make a design of a familiar object or scene. You may want to sketch the design on paper first. Transfer the design to the Plexiglas by scratching the surface with a nail. Use crosshatching to create texture and shading.

When your design is complete, rub a bit of water-soluble printing ink over the surface. Make sure you get ink into all the scratch lines. Wipe the ink gently off the surface with a paper towel or rag, leaving ink in the scratches. Place a piece of damp drawing paper face down on the Plexiglas. Use your fingers or the back of a spoon to push the paper into the scratch lines until the image has transferred.

148

Daily Warm-Ups: Art

Canvas Captions

- reproductions of paintings by Jan Vermeer or Diego Velázquez

- pencil and paper

Look carefully at a reproduction of a painting by either Jan Vermeer or Diego Velázquez. What do you see in the painting? What is happening? If there are people in the painting, what do you think they are saying?

Write a caption that explains what is happening in the painting, or write speech bubbles to show what each person in the painting is thinking or saying.

149

Realism in Art

- reproductions of works by Francisco Goya and Honoré Daumier

- paper

- drawing materials

During the nineteenth century, artists such as Francisco Goya and Honoré Daumier started painting events that were then taking place in the world. Artists captured news events and life as it was from the common person's perspective.

Think of a current event, either in your life or in the world at large. Draw the event as a way of sharing it with others. Make your version as objective as possible. Your work must be able to get the message across on its own without the use of captions. Share your completed drawing with the class to see if others can tell what message or event you are trying to present.

150

Daily Warm-Ups: Art

Art Appreciation

Jean-François Millet

- reproductions of Millet paintings
- drawing paper
- pencil
- colored media (colored pencils, markers, and so forth)

French painter Jean-François Millet was the son of a peasant farmer. As an adult, he painted the peasants of the French countryside going about their work. The people in his paintings are working steadily and getting the job done, but they often seem to dominate the landscape. The paintings are created in a way that gives these common working people a certain pride.

Can you draw someone calmly working at an everyday task and make both the person and the task appear important? Choose colors or values that support the subject and the task.

151

Thomas Cole

- reproductions of Thomas Cole landscapes

- drawing paper

- pencil

Nineteenth-century landscape artist Thomas Cole was associated with the Hudson River School. Large panoramic vistas were popular subject matter for this group. With turmoil and corruption in Europe, the public loved these romanticized paintings of unspoiled land. Cole captured flawless landscapes that looked as if the viewer was there. Study some of Cole's paintings to see how he achieved this effect.

Look out of a window or at a photograph of a landscape. Try your hand at drawing what you see. Eliminate any signs that people—other than you—have set foot in the area you are drawing. Your scene should draw viewers in and make them wish they could go there to escape the hustle and bustle of everyday life.

152

Color Patches

- reproductions of Paul Cézanne's landscape paintings

- drawing paper

- oil pastels or crayons with the paper covering removed

Look at one of Paul Cézanne's landscape paintings. Note that his application of color is rather blocky and objects are not well defined. Despite this, his work gives viewers the sense that the landscape is not imaginary but shows a place that really exists.

Try to create a landscape using the sides of crayons or oil pastels. Do not begin with an outline. Instead, instead build up layers of color to develop the landscape.

Daily Warm-Ups: Art

153

Art Appreciation

Claude Monet

- reproductions of Claude Monet's landscape paintings
- drawing paper

- watercolors
- brush
- water

Look at a Monet landscape. Can you tell what time of year and day it shows? Monet was a master at capturing the subtle surface effects of light. He often had several canvases of the same scene going at once. As the light changed, he would change his canvas.

What is your favorite time of day? How are the colors different then than at other times? One clue to the time of day in a painting can be the shadows: They are longer early and late in the day and shorter in the middle of the day.

Create a watercolor sketch of a tree at your favorite time of year and day. Keep the light in mind. For example, lighter, warmers colors with short, dark, contrasting shadows suggest afternoon better than colors that are close in value and intensity.

Share your finished picture with a classmate. Can your classmate tell what time of year and day it shows?

Daily Warm-Ups: Art

Daily Warm-Ups: Art

Art Appreciation

Weather-Inspired Movement

- reproductions of Vincent van Gogh landscapes
- glue
- black or white paper
- colored chalk

Do you like watching a thunderstorm or other weather event? What color changes take place? Vincent van Gogh's paintings often show wind and other aspects of weather.

Look at a reproduction of a Vincent van Gogh landscape, such as *The Starry Night*. What time of day does the painting show? What clues make you think that? What time of year is it? Why do you think that? Observe van Gogh's use of color and line. How has he used it to create a sense of weather and move your eye through the painting?

Choose a type of weather to represent. Think about what type of mark would suggest this type of weather. For example, you might use swirling lines to represent wind. Using glue on black or white paper, create lines to suggest the weather you chose. While the glue dries, experiment to find a combination of chalk colors that would add to the effect of your composition. When the glue is fully dry, highlight it with colored chalk.

155

Art Appreciation

Georges Seurat

- reproductions of Seurat paintings

- drawing paper

- paint and brushes

Seurat approached painting from an intellectual and scientific point of view. His paintings were carefully and deliberately calculated. He did not use brushstrokes but instead placed small dots of color next to one another. His carefully chosen colors were painstakingly placed on the canvas in order to achieve certain results. For example, where green was needed, he might place dots of yellow alongside dots of blue; the viewer's eye would blend the dots to form green. Light and dark values next to each other helped create areas of brightness or darkness.

Experiment with blending color by putting small dots of two primary colors beside each other. Move a little bit away from the paper. Do you "see" a secondary color? If not, you may need to try more dots. Try dotting one primary and one secondary color to visually blend intermediate colors.

156

Daily Warm-Ups: Art

Art Appreciation

Musical Inspirations

- drawing paper
- pencil
- colored pencils or markers
- musical recording that suggests a mood

Russian painter Wassily Kandinsky compared artists to composers of music. He felt that color and shape powerfully affected the emotions much in the way music can. Kandinsky's spontaneous-looking works are often named "Improvisation" or "Composition."

Listen to the music that is playing. What type of mood or emotion does it stir in you? If the music is soothing, how can you visually depict that? If the music has movements that are abrupt and loud, how can you visually describe them?

Try visually expressing the way the music makes you feel without using representational objects. Use various colors, lines, and shapes to express emotion.

157

"Wild Beasts"

- reproductions of Fauve landscapes
- drawing paper
- pencil
- oil pastels

In 1905, a group of painters had a show in Paris. Art critics were horrified by what they saw. One critic called the painters *les fauves*, or "wild beasts." The painters used strong, bright colors to express the way they felt about their subjects. Fauve painters included Henri Matisse, André Derain, Maurice de Vlaminck, and Georges Rouault.

Look at some Fauve landscapes. Observe their use of contrasting color and shape. The Fauves approached landscape painting in a nontraditional way. Their landscapes vibrate with color. The shapes are simplified; sometimes they seem more like patterns than parts of a landscape.

Sketch a simple landscape. Then use oil pastel to add bold, bright areas of contrasting color. Don't worry about the "real" colors of a landscape; use color to express feelings. You might decide on a purple and blue sky, or yellow and orange trees. Try blending various values of a color to add depth. Remember that dark, warm colors appear to come forward, while lighter and cooler colors seem to recede.

Daily Warm-Ups: Art

158

Art Appreciation

Piet Mondrian Collage

- reproductions of Piet Mondrian paintings

- narrow strips of black paper

- squares and rectangles of paper in red, yellow, and blue

- background paper

- glue stick

Look at a reproduction of a Piet Mondrian composition such as *Composition in Blue, Yellow, and Black.* Notice the way Mondrian used a limited palette and contrasting combinations of vertical and horizontal lines to create a sense of balance and unity.

Arrange the black strips and primary-colored rectangles on a piece of paper until your composition seems balanced. Experiment with both symmetrical (formal) and asymmetrical (informal) combinations. When you have a satisfactory combination, glue it in place.

159

Analytical Cubism

- reproductions of Cubist paintings

- drawing paper

- pencil

A realistic painting or photograph shows its subject in a static pose. When we look at an object, however, we are not static. We move our heads to see the object from different angles, step back or move in closer, even walk around the object to look at the other sides. Cubist artists tried to capture the idea of painting an object on a flat canvas from simultaneous points of view.

Choose an object in the room, such as a desk or chair. Draw it simply, from where you are sitting. Then change your perspective or angle and draw it again, connecting the new drawing to the first drawing. Continue changing your vantage point, drawing and connecting the drawings, until you have filled the page. Your completed composition will appear abstract but should have a sense of movement.

Daily Warm-Ups: Art

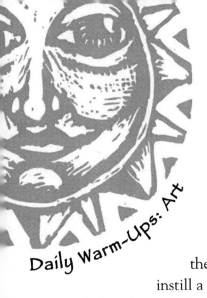

Art Appreciation

Murals

- reproductions of murals by José Clemente Orozco and Diego Rivera

- paper

- drawing materials

José Clemente Orozco and Diego Rivera created many murals in Mexico and the United States. In their works, these artists emphasized the history and culture of their people. Their work was designed to help instill a sense of national pride and to validate the culture of the Mexican people before the arrival of Europeans. On more than one occasion, these murals caused controversy. Sections of murals had to be redone or removed.

Choose a patriotic theme that you feel passionate about. Create a sketch for a mural. At the bottom of your sketch, name the place where you propose to paint this mural. Exchange designs with a classmate. What reaction do you have to your classmate's design?

161

Marc Chagall

- reproductions of paintings by Marc Chagall

- drawing paper

- pencil

What comes to mind when you look at a Chagall painting? What is the symbolism? Why do you think he painted objects using unusual colors?

Daily Warm-Ups: Art

The colorful fantasy paintings of Marc Chagall are journeys into a personal world in which the artist has used unconventional methods to express universal themes. Most Chagall paintings contain some element that is universally recognizable, such as a wedding and music, or flight from something frightening.

Have you ever experienced a situation that seemed mixed up, such as a bright, happy event countered by darker moments? Using the style of Chagall, do a quick drawing of such a personal event.

162

Art Appreciation

Georgia O'Keeffe

- reproductions of paintings by Georgia O'Keeffe
- objects or photographs to draw
- viewfinder
- drawing paper
- pencil

Look at the abstract works of Georgia O'Keeffe. Much of her inspiration came from the natural world. What types of natural objects has she chosen to paint? How do you think she has abstracted the objects?

Choose an object or photograph. Look at it through a viewfinder. Start by holding the viewfinder close to the object or photograph. Slowly move it away. Isolate an area that appeals to you.

Imagine that the edges of the viewfinder are the same as the edges of your paper. Reproduce what you see inside the viewfinder on the paper by enlarging the area you have selected to fill the paper as the image fills the viewfinder. Has isolating and drawing a small part of the original image made your finished drawing an abstract design?

163

Alexander Calder

- photographs of Alexander Calder mobiles

- cardboard

- string

- scissors

Until Alexander Calder put together perfectly balanced organic shapes suspended by wire, art was static. It hung framed on the wall or sat in a room or garden for people to admire. By comparison, Calder's mobiles seemed alive. They were so perfectly balanced that the slightest wind current caused them to twist and dance in midair, creating an ever-changing work of art.

Using cardboard and string, try to connect shapes so that they are perfectly balanced and the slightest movement of air causes the pieces to slowly move about.

Daily Warm-Ups: Art

164

Louise Nevelson

- reproductions of sculptures by Louise Nevelson

- scrap wood

- paper for background

- glue

Using the simplest of form and color, Louise Nevelson created wood sculptures that draw the viewer in. The shadows help create an interesting surface quality that changes with the light.

Look at an example of Louise Nevelson's work. Compare the work to its title. Can you see a connection?

Arrange pieces of scrap wood on a background. Pay attention to the negative space as well as the positive space—both should be equally interesting. When you have created a pleasing composition, glue the pieces to the background. Give your work a title.

165

Daily Warm-Ups: Art

Mark Rothko

- reproductions of paintings by Mark Rothko

- drawing paper

- color media (paint, markers, colored pencils)

This twentieth-century painter moved away from representational painting. His paintings have large blocks of color with softened edges that appear to be suspended on the canvas. Each painting was designed to be hung alone or with another of his works. These abstract paintings are intended to make the viewer feel a particular way.

Imagine entering a gallery space and seeing a wall covered with Rothko's huge, colorful paintings. What type of reaction do you think you might have? Look at a Rothko reproduction. What kind of mood or feeling does it give you?

Color or paint a sheet of paper one color or various values of one color. On top of this color, paint two or three large blocks of colors with diffused edges.

Does your work represent how you feel today?

Jacob Lawrence

- reproductions of paintings by Jacob Lawrence
- colored paper
- scissors
- paper for background
- glue

Daily Warm-Ups: Art

Jacob Lawrence found his inspiration in the history of his people and in everyday Harlem life. His use of bold, flat color is reminiscent of cut paper. Figures are reduced to their simplest shapes, yet there is never any doubt as to the story being depicted. There is strong compositional movement as the artist masterfully leads your eye through his work.

Think of an event in history or in your life that is important to you and that you would like to visually share with others. Design a composition using cut paper to show this event. Think about how you will arrange the images. What do you want viewers to notice first? Second? Third? How will your size and color choices affect the end result? When you are happy with the arrangement, glue the cut paper to the background.

167

Roy Lichtenstein

- reproductions of paintings by Roy Lichtenstein

- paper

- drawing materials

- color media

Much of this Pop artist's work was inspired by the art of commercial comic strips. His color application is bold, the images often dramatically cropped, more than life-size. He covers areas with the type of dot pattern seen in newspaper images under magnification.

168

Try turning one ordinary activity that you have done today into a frame of a comic strip. Use size, perspective, cropping, and color contrast to portray the ordinary as if it were extraordinary. Dramatize each aspect that you draw.

Daily Warm-Ups: Art

Art Appreciation

Faith Ringgold

- reproductions of Faith Ringgold's story quilts

- drawing paper

- colored pencils

Observe an example of one of Faith Ringgold's story quilts. She has chosen cloth as her artistic medium. Quilts have been created by hand for centuries. Their primary function, as beautiful as many of them were, was utilitarian: to keep people warm. Ringgold's story quilts cross the boundary between functional and nonfunctional. Her biographical work speaks to current history yet seems connected to the past because it is created through quilting.

Think of an important event from your past—perhaps a special gift you received, or the birth of a sibling. Create a drawing to represent the event. Give the drawing a quilt-like border using symbols or shapes that tie in with your overall design.

169

Environmental Art

- photographs of installations by Robert Smithson or Christo

- paper

- drawing materials

Look at the works of Robert Smithson or Christo. What do you think might be involved in constructing such monumental works of art? Preparation would include building permits, easements, and making exact calculations so that the whole concept actually works. These works are normally short-lived or located in remote sites. They are documented in film and photographs so that more people can see them.

Where could you place an environmental work? Would you make something that blends in and causes people to do a double-take when they notice it? Or would you make something that stands out? What material would you use? Why would you use it? What legal obstacles might you need to overcome before installing such a piece?

Work out an idea for an environmental piece. Then develop a sketch of your idea.

170

Art Appreciation

Andy Goldsworthy

- photographs of works by Andy Goldsworthy

- natural objects, such as bark, driftwood, feathers, shells, twigs

Having worked as a farm laborer in his teens, Andy Goldsworthy is well acquainted with the countryside. He works within nature as well as with natural objects to create timeless sculptures that range from the remarkable to the whimsical. At first glance, they appear effortless to construct. Photography is an integral part of his artistic process. When working in nature with natural objects, nothing is permanent; what comes from the earth eventually returns to the earth. Photographs serve both to document Goldsworthy's sculptures and to provide a means for people to view them.

Use a handful of natural objects. See what sculptural form you can create without using glue, tape, or other modern fasteners.

171

Pop Art

- reproductions of work by Pop artists such as Andy Warhol

- paper

- drawing materials

Claes Oldenburg referred to Pop Art as art that is as "sweet and stupid as life itself." His inspiration came from what he saw around him in everyday life. Andy Warhol is probably the artist most closely connected to the Pop Art movement. Warhol took the ideas of mass media, commercial art, and mass advertising—the way that our culture bombards us with bright, simplified, repetitive images— and used them in his work.

Look around the room. Draw as many logos as you can see on your classmates' clothing, shoes, and accessories.

172

Daily Warm-Ups: Art

Art Appreciation

Going to the Dogs

- reproductions of paintings by one of your favorite artists

- paper

- drawing materials

Some artists have such a distinctive style that their paintings are immediately recognizable. You don't need a signature to know that they painted a picture.

Choose a work of art by one of your favorite artists. Look closely at the picture you've chosen. What is it that makes the painting style so recognizable? Is it the way the paint is applied? The use of color? The brushstrokes?

Assume that this artist had a pet. Use a style representative of this artist to create a whimsical portrait of the artist's dog, cat, fish, or other pet.

173

Symbols as Art

- reproductions of paintings by Keith Haring

- drawing paper

- pencil

- colored pencils or markers

Look at the work of twentieth-century artist Keith Haring. What kind of rhythm does the picture have? What elements or principles of design do you think create the rhythm? Do you like the picture you are looking at? If so, why? If not, why not?

Think about the many symbols you see on a daily basis. They might include symbols in school, road signs, pedestrian crosswalks, or railroad crossings.

Choose one or two familiar symbols and use them to create a rhythmic design. Add any elements and principles of design you feel you need to create a strong sense of rhythm.

174

Artful Idioms

- drawing paper

- pencil

All languages use idioms. These are phrases that are familiar to people who speak the language, but whose meaning is not in the actual words. For example, English speakers know that "keep your fingers crossed for me" means "wish me luck"—but the words of the idiom have nothing to do with that meaning. Other English idioms include phrases like "raining cats and dogs," "between a rock and a hard place," "bats in your belfry," "on the cutting edge," "a horse of a different color," "off the top of my head."

Think of a few idioms, and what they really mean. Choose one idiom. Make a drawing that clearly expresses the idiom that was the source of your inspiration.

Daily Warm-Ups: Art

175

Op Art Line Drawing

- drawing paper

- fine-point black marker

Imagine that you are driving a car on a straight road and have to swerve to avoid hitting an object. After swerving you continue driving straight until you reach your destination.

Using a fine-point black marker, draw five circles of random size and placement on your paper. Beginning at the top center of the paper, draw a vertical line down to the bottom. When you come to a circle in your path, stop just before touching it and draw around the circle.

Once you reach the bottom of the page, return your marker to the top of the paper. Draw another line to the right of the first one, parallel to it.

Keep repeating this process. Try to make your lines close to each other and consistently parallel. This will make the final design more effective.

Once you have filled in the right half of the paper, do the same thing on the left side until the entire page is filled.

176

Sun Symbols

- reproductions that show sun symbols

- drawing paper

- pencil

- colored pencils or markers

Examine a variety of sun symbols. You can begin your examination with the two that appear on this page. Another source of inspiration might be the many ancient cultures that used sun symbols in petroglyphs. How is the sun often shown in young children's drawings? Are there any common principles of design in the examples you've looked at?

Create your own stylized version of the sun. Then write a short paragraph that explains where your inspiration came from.

Daily Warm-Ups: Art

177

Art Appreciation

Futurists

- reproductions of works by Futurists such as Giacomo Balla or Umberto Boccioni

- paper

- drawing materials

Futurist artists believed that art should be forward-looking. Their work has the appearance of movement and speed. Look at examples of this style by painter Giacomo Balla or sculptor Umberto Boccioni. Repeated or exaggerated leg motions, for example, create a blur as though the figure is moving swiftly before the viewer's eye.

In your mind, picture an activity that involves motion, such as throwing a ball, running, dancing, and so forth. Draw someone performing the action. Add repeated body parts to indicate motion. Does your drawing create a sense of movement?

178

Mood of a Portrait

- reproductions of portraits by Vincent van Gogh, Pablo Picasso, or other artists

- drawing paper

- drawing materials

- color media

Look at examples of portraits by artists such as van Gogh or Picasso. How do you feel the artist's use of line, shape, and color helps to portray the mood of the sitter? As the viewer of the work, how do the colors make you feel?

Determine what type of response you would like to evoke in viewers of a portrait you have created. Create a portrait using colors, lines, and shapes to get your message or mood across.

Daily Warm-Ups: Art

179

Depicting History

- reproductions of Francisco Goya's *The Third of May, 1808* and Pablo Picasso's *Guernica*

- paper

- pencil or pen

Daily Warm-Ups: Art

Many artists have chosen acts of war as their subject matter. Some artists painted from actual experience at the scene. Others were moved to paint as a means of recording or dealing with a tragic event. Spanish painter Francisco Goya's *The Third of May, 1808* shows Napoleon's soldiers executing Spaniards in Madrid, Spain in 1808. Pablo Picasso's *Guernica* is a huge painting, over 25 feet long, that reflects the horror of the 1937 German bombing of Guernica, Spain. The two paintings are very different in style. But both depict the horrors of war.

Generate a list of current events that have moved you in some way. As an artist, how could you share your feelings about this event with others? Write five possible approaches. If time allows, make some quick sketches for each idea.

180

Elements of Design: Line

1. **Cardboard Printing**
 Preparation: Any type of scrap cardboard (corrugated, railroad, mat board, and so forth) will work for this project. If desired, cut the cardboard strips in advance. Palettes with a large, flat surface are best for this project. If none are available, Styrofoam meat trays or plates work well.

2. **Wire Figure Gestures**
 Preparation: Choose two students to be the models for this exercise. Each student should do five 10-second poses. Sharing the task allows the models to draw as well as pose.
 Extension: Have students add form to the wire gesture in order to create volume. Aluminum foil and ParisCraft work well.

3. **Take a Bite**
 Preparation: Prepare 6-inch-by-24-inch strips of drawing paper in advance.
 Extension: Have students turn their drawings into a flip book that shows the apple being eaten.

4. **Ink Lines**
 Extension: Have students work back into dry lines, bringing out and/or adding details to any images they see within the lines.

5. **Life Lines**
 Encourage students to work large, using the entire paper.

6. **Invented Line**
 Extension: Have students switch to another drawing tool (e.g., marker, chalk, or even paint).

7. **Blind Contour Drawing**
 Answers will vary. Students often find it difficult to draw without looking at the drawing, and are surprised to find that the drawing usually turns out well when they focus on really looking at the subject, instead of focusing on how the lines look on the paper.

8. **When Line Becomes Shape**
 Students often find it difficult to create a three-

dimensional shape without drawing it first.
Encourage them to spend at least five minutes try-
ing to form the shape without a visual to work
from. If they start becoming frustrated, suggest
that they draw the shape first, then form it in
three dimensions. To close up the first triangle,
suggest that they form a large knot in the thread,
then run the needle and thread all the way
through three straws. Bring the needle back to the
starting point and run it through the knot. With
the first triangle firmly in place, it is usually quite
easy to add straws for the other triangular faces of
the pyramid.

Elements of Design: Color

9. **Complementary Colors**
 This activity can be used as a springboard for a
 discussion on color theory.
 Answers will vary. Students should notice that
 they "see" the shape of the object they looked at,

but the image has the color of the actual object's
complement.

10. **Color Practice**
 Preparation: If you wish, provide students with
 examples of each of the color schemes listed in the
 activity, or give them the following definitions:
 • Primary colors: red, blue, and yellow (no two
 colors can be blended to make them)
 • Secondary colors: green, violet, and orange (two
 primary colors can be blended to make them)
 • Intermediate colors: yellow-orange, yellow-
 green, green-blue, blue-violet, red-violet, and
 red-orange (colors made by blending one pri-
 mary and one secondary color)
 • Analogous colors: colors next to each other on
 the color wheel
 • Warm colors: reds, oranges, yellows
 • Cool colors: greens, blues, violets
 • Triadic colors: colors that form an equilateral
 triangle on the color wheel

- Complementary colors: colors that are opposite each other on the color wheel
- Value: lightness or darkness of a color
- Color spectrum: red, orange, yellow, green, blue, indigo, violet (ROYGBIV)

11. **Color Intensity Practice I**
Students should find that overlaying a color with its complement reduces the intensity of the color, making it appear more neutral.
Extension: Have students repeat the activity on the same sheet using different pairs of complementary colors.

12. **Color Intensity Practice II**
Answers will vary. Students will probably find the colors more intense in the primary/complementary pairing.

13. **Color Intensity Practice III**
Answers will vary. Students will probably find the colors more intense in the primary/complementary pairing.

14. **Tints and Shades**
Extension: Have students try additional colors, or create a color wheel with tints toward the center moving to pure color, then shades toward the outside edge of each color.

15. **Making Neutral Colors**
Extension: Have students try the same experiment using watercolor, tempera, and/or acrylic paint.

16. **T-shirt Design**
Extension: Have students draw and color in ten variations of the same graphic to compare results.

17. **Landscape Colors**
Extensions: 1. Blur a landscape image on the overhead projector and have all students work from the same image. 2. Have students complete the landscape drawing by adding details on top of the blocked-in colors.

18. **Photo Match**
Preparation: Before assigning this project, choose appropriate photographs and cut them in half. If

needed, ask students to bring in magazines several days before doing this activity.

19. **Color Spinner**
Preparation: You may prefer to have the poster board circles prepared in advance for this activity. Students' answers will vary. Sample answer: The colors blended into each other.

Elements of Design: Value

20. **Brown Paper Lunch Sack**
Preparation: Provide a brown paper lunch sack for each student.

21. **Pencil Value Scale**
This activity works best if students have medium pencils, neither very soft nor very hard.

22. **Pen Value Scale**
Encourage students to use the pen in one direction only, without crosshatching.

23. **Crosshatch Value Scale**
Extension: Have students create additional value scales using multiple layers of crosshatching in different directions.

24. **Stippled Value Scale**
Extension: Have students create additional value scales by varying the size of the dots as well as the spacing.

25. **Color Value**
Encourage students to save these color value scales for future use.

26. **Landscape Proportions and Value**
Preparation: You may want to introduce this activity by projecting a transparency of a landscape drawing and pointing out the foreground, middle ground, and background of the drawing.

27. **Ink Wash**
Extension: Have students repeat the activity using colored ink or watercolors.

Elements of Design: Texture

28. **Simulated or Implied Texture**
Encourage students to imagine how different media and applications can suggest different textures. Have them identify different textures in the

room—for example, the ridged or knobbed sole of a shoe or sneaker—and suggest ways of re-creating that texture.

29. **Tactile Texture**
Preparation: Before doing this activity, prepare pie tins with a layer of sand or salt that just covers the bottom.

30. **Drawing How It Feels**
Preparation: Before class, place small objects in brown paper bags. Use items with distinctive shapes and textures such as pinecones, unusually shaped fruit (star fruit, kiwi, miniature pineapples), vegetables, hardboiled eggs, coarse rocks, smooth pebbles, and so forth. You may want to provide a bag for each student, or for pairs or small groups, or one bag for the whole class, calling students up by row. Students are often surprised to find that their drawings look like the objects they touched, even when they were unable to identify the objects.

Extension: Give each student a bag with a mystery object. Have them tape their paper down to keep it from moving. Then, with their eyes closed, have them do a contour drawing of the mystery object. They may want to touch the object with one hand while they draw with the other hand.

31. **Surface Quality**
Preparation: You might show students collages using painted papers, such as those of Henri Matisse or Eric Carle, as part of this activity.

32. **Observing and Re-creating Texture**
Preparation: Provide objects with interesting surface quality for students to draw, such as driftwood, eggshell, velvet, chrome. If you use larger items you may want to have students work in groups. Avoid items that have a distinct pattern, as the pattern may become a distraction.

33. **Glue Texture**
Extension: Once it is dry, this project can be drawn upon, using chalk, oil pastel, or paint.

For added interest the glue can be colored by adding a bit of tempera or acrylic paint.

34. **Texture Rubbings (Frottage)**
Extensions: 1. Have students write about a situation in which they might prefer using a collected texture rather than drawing a texture in their artwork. 2. Have students create two pieces of art, one using simulated textures and one using collected textures.

35. **Textured Landscape**
Some students find it difficult to "see" textures that they can borrow. If necessary, encourage them to try taking rubbings of various surfaces on a test piece of paper so that they can visualize the pattern that will be transferred.

36. **Bubble Printing**
Preparation: Prepare the paint solution before students arrive. Mix a dab of tempera paint and a drop of dish liquid in the bottom of a cup (an eight-ounce yogurt container works well). Half-fill the cup with water and slowly stir. Test the color by making a sample bubble print. If the color is not to your liking, adjust the value by adding more paint (to darken) or more water (to lighten).

Elements of Design: Shape

37. **Shadow Tracing**
Preparation: This is a wonderful activity to do outside. If that is not an option, shine a spotlight on various still life objects.

38. **Finish the Picture**
Extension: Have students draw six different shapes or shape combinations and swap them with the person sitting nearest to them for the other person to complete.

39. **Tool Trace**
Preparation: Provide a variety of small tools for this activity, avoiding anything too heavy, too sharp, and so forth. Interesting choices include wrenches of different sizes and shapes, pliers, paint scrapers, can openers, etc.

Extension: Have students add pattern, color, and texture in such a way that the tool remains the emphasis and is not overpowered and obscured by the additions.

40. **Four Shapes, Four Looks**
 Extension: Have students introduce color into their drawings to see how that changes the overall effect.

41. **Exploring Negative Shape**
 Pre-cut 4-inch-by-4-inch oak tag. Cut enough that students can use more than one piece each.

42. **Exploring Positive and Negative Shape**
 Preparation: Pre-cut 4-inch-by-4-inch squares of oak tag; cut enough to give students more than one piece each.

43. **Scribble Deer**
 Extensions: 1. Have students try scribbling one deer beginning at the head and working down the body to the legs. Next, see what kind of results

they get if they begin with the body and work outward to the head and legs. 2. Have students try other animals. 3. Have students draw a scribble animal by creating the image on top of something textured (e.g., a rock, corrugated cardboard).

44. **Floating Boxes**
 Extension: Have students add contrast color in the negative space that surrounds the floating boxes.

45. **Finding Simple Shapes**
 Preparation: Provide students with clear photographs of animals.
 Extensions: 1. Show students pages from a book on drawing animals, where the artist uses simple shapes to describe the animals' forms. Compare the shapes in the book to the shapes students identified. 2. Have students redraw their simple shapes onto a piece of drawing paper, then add details like those they observed in the photograph.

Elements of Design: Form

46. **Playing with Food**

Preparation: Provide a potato for each student. If having students use paring knives is not an option, cut the potatoes into uneven chunks before doing the activity.

Extension: Have students take apart their creations, pull out all the toothpicks, then put a small dab of paint or water-based ink on a palette. They can use their finger to rub ink onto pieces of potato and create a stamped design on paper.

47. **Tube Design**

Extensions: 1. Have students glue one of their designs to a piece of heavy paper or card stock. The design could be taken further by painting it. 2. Have students make several tube designs and paint each using a different technique—for example, using contrasting colors, patterns, and so forth.

48 **3-D Brainstorming**

Preparation: Provide each student with the same seven objects of your choice. Objects should be simple, easily obtainable items such as toothpicks, paper plates or cups, napkins, straws, and string.

49. **Odd Object Container**

Preparation: Select an oddly shaped object for the class to look at and use as a source of inspiration for this project.

Extension: Have students finish their packages so that they are eye-catching as well as functional.

50. **Stick Figures Gain Weight**

Extension: Photograph or videotape your students in a pose, then let them work from their own image. This can be a nice introduction to either figure sculpture or figure drawing.

51. **A Limiting Factor**

This is a good activity for helping students look at shapes in different ways.

52. **Forms in Space**
 Extension: Have students add color and/or value to their drawings.

53. **Found Object Sculpture**
 Preparation: Provide five or six small objects for each student. They might include old marker caps, broken or unusable pencils, buttons, game pieces, and so forth. Scrap wood can also be used as an extension to this project; students can then paint and add pattern to the dried sculpture. Try to include a variety of shapes and surfaces for each student.

54. **Slice and Wedge**
 Use this activity to encourage students to think three-dimensionally. Some students may find it hard to visualize the finished structure and will want to sketch the shape in first. Encourage them to continue working in three dimensions rather than reverting to two dimensions.

55. **In The Year 2525**
 If they are available, provide students with visual aids such as images of cityscapes, spaceships, and industrial plants. This can also be used as a lead-in to a discussion of issues such as the environment and population growth.

Elements of Design: Space

56. **The Space Between**
 Extensions: 1. Have students further cut apart the shape and manipulate it into other interesting balances between positive and negative. 2. Have students add other shapes.

57. **Worms In Outer Space**
 This is a good way for students to practice overlapping shapes. When students have finished, have them compare drawings. It is always interesting to see how many different designs people can develop from the same set of directions.
 Extension: Have students add color and/or pattern to the worms and background.

58. **The Illusion of Depth**
 Extension: Have students add color to their drawings.

59. **Hole in the Page**
 Have students compare completed drawings. See how many unique ideas they came up with and how many similar ideas were repeated.

61. **A New Perspective**
 Preparation: Provide each student with a mug or paper cup for this activity.

63. **Rock Conquer**
 Preparation: Have enough interestingly shaped rocks available so that each student can have a choice.

64. **Appearing Hand**
 If students have faithfully drawn the negative spaces, they should find that, without trying to, they have drawn their hands.

Principles of Design: Pattern

65. **Pattern Fill-in**
 Extension: Have students fill in the background with pattern as well, making sure that it contrasts with the patterns used inside the shapes so that the shapes do not become lost.

66. **Hair Lines**
 Preparation: Have students team up for this exercise.

67. **Tessellations**
 Preparation: Cut squares of 2-inch-by-2-inch oak tag and 8-inch-by-8-inch drawing paper before class. If available, reproductions of M.C. Escher tessellations or Islamic tiles can also be helpful.
 Extension: Have students fill the tessellation with pattern and/or color, which allows both the pattern and the shapes to be seen at their best.

68. **Rug Inspired Design**
 Preparation: Rather than having students cut paper shapes, you can provide them with pre-cut shapes. To provide enough reproductions of Navajo rugs for the whole class, you may want to have students work in groups and give a few reproductions to each group.

72. **Use Your Name**
 Extension: Have students color in their patterns using one of the following color schemes: a pair of complementary colors; a pair of analogous colors; monochromatic tones; neutral colors.

73. **Background Pattern**
 Preparation: Provide students with a selection of items with a low relief or texture. Pieces of patterned vinyl tablecloth or placemat work well for this exercise, as do glue designs described in Activity 33, Glue Texture.
 Extension: Use the paper created in this project to draw into, or cut it up and use it in a collage.

74. **Crossword Puzzle Patterns**
 Preparation: Provide students with copies of crossword puzzle grids.

Principles of Design: Contrast

75. **Contrasting Materials**
 Preparation: Provide students with a selection of magazine pictures to choose from.

77. **As Plain as Black and White**
 Preparation: Choose simple objects for students to draw. Objects such as paper clips, Band-aids, Q-tips, scissors, and so forth work well for this activity.

78. **Rock Strata**
 Preparation: Rocks such as sandstone work well for this activity. Science labs can be a wonderful source of interesting drawing visuals. If you do not have access to examples of sedimentary rocks, try science books or search the Web for color images of suitable rocks.

80. **Surreal Interiors**
 Preparation: Provide students with a selection of glossy magazines for this activity. If you wish, tear pages from the magazines before class. You may want to show them reproductions of paintings by surrealist painters such as Max Ernst, Salvador Dali, Frida Kahlo, and René Magritte.

81. **Monoprint**
 Preparation: Provide a selection of objects to remove ink, such as cardboard scraps, marker caps, plastic fork, and similar objects. An old shower curtain works well as the plastic sheeting.
 Extension: Have students use oil pastels to hand-color their dry prints.

82. **Color Contrast**
 Extension: Have students use analogous colors, monochromatic combinations, cool and warm colors, different values, or a different color border around one or both shapes.

Principles of Design: Balance

85. **Kaleidoscope Design**
 Preparation: Wooden spoons or the handles of a pair of scissors can be used as burnishing tools.
 Extension: Have students add color to this radial design.

86. **Paper Drop**
 Preparation: Pre-cut long, narrow strips of colored paper, about 1/4 inch by 6 inches. Also pre-cut

(or, if available, use a die-cut machine) small geometric and/or organic shapes. Give each student a handful of strips and a handful of shapes.

87. **Symmetrical Balance**
 Preparation: Pre-cut 6-inch-by-6-inch squares of paper in primary colors. Give each student one square of each primary color.
 Extension: Have students try different color combinations to see how color can affect the mood of a design.

88. **Asymmetrical Balance**
 Preparation: Pre-cut 6-inch-by-6-inch squares of paper in secondary colors. Give each student one square of each secondary color.
 Extension: Have students try different color combinations to see how color can affect the mood of a design.

89. **Radial Design**
 Preparation: Pre-cut 4-inch-by-4-inch squares of graph paper. Graph paper with four spaces per

inch works well, but any type of graph paper will do.

91. Visual Balance

Preparation: Provide students with paper shapes in assorted colors and sizes.

Extension: Spread out student results and discuss their findings.

Principles of Design: Rhythm

92. Rhythm Design

Extension: Have students use the design to create an embossing. Dampen a piece of watercolor paper large enough to cover the design. To dampen the paper, soak it in water, spray with a spray bottle, or use a clean wet sponge. Place the paper on top of the cardboard design and run it through a printing press. If no press is available, students can carefully (so that it won't tear) rub the surface of the design with the back of a wooden spoon.

94. Go with the Flow

Preparation: Provide each student with a floppy disk to examine.

95. All Stuck Up

Students can share tape by attaching a long piece of each color they want to the sides of their desks and cutting or tearing pieces from the strip.

98. Circles

Extension: Have students share their drawings to see if the object and the movement are clear to others.

99. Straw Rhythm

Preparation: Provide each student with a handful of paper drinking straws.

Principles of Design: Movement

100. Recorded Movement

Preparation: Provide a variety of magazines for students to look at. You may want to ask students to bring in magazines a few days before doing this activity.

101. Recorded Action Lines

Extension: Have students exchange paint trays with someone using a different color. Have them

record what happens where the colors cross. What type of color has been created?

105. **Rope-Making**
Background: Fiber has a long history in the arts from both an artistic and a practical standpoint, from the finely knotted carpets created throughout much of the eastern hemisphere to utilitarian rope. Contemporary fiber artists often incorporate rope into their work. Early settlers in America used a technique similar to the one explained here to make rope. Once the technique is learned it will be easy for students to see how they could turn rope into a fiber sculpture.
Preparation: Students should work in pairs on this activity. Each student pair will need enough space to be able to stand about 6 feet apart.

106. **Flip Books**
Preparation: If available, you may want to show students some of Eadweard Maybridge's motion-study photographs.

107. **Star Trace**
Preparation: Large double stars can be photocopied before class rather than having students draw them.

108. **Motion Lines**
Preparation: Have cartoons showing motion lines available for students to look at. Keith Haring's work is often a wonderful source of motion lines.

Principles of Design: Emphasis

110. **Place the Emphasis On . . .**
Students may find it easier to identify an interesting section to emphasize if they use a simple viewfinder to isolate areas.

111. **Horizon Lines**
Extension: Have students sketch similar landscapes on their three horizon lines and observe how the change in the horizon line affects the landscape.

115. **Botanical Names**
Preparation: Before class, search flower catalogs

or the Web for flowers with names that suggest images, such as bachelor's button, cowslip, jack-in-the-pulpit, and so forth. Place the names in a container where students can reach in and select one. The names can be put back for future use.

Principles of Design: Unity

117. Building a Mystery
Preparation: Gather small objects such as old airline or concert tickets, a candlestick, a pocket watch, an envelope with a letter, and so forth. Use them to set up small still lifes for students to quickly draw and then write about.
Extension: Have students do a more detailed drawing or painting.

119. Organizing Odd Shapes
Preparation: Provide a variety of magazines for student use. You may want to ask students to bring in magazines a few days before doing this activity.

120. Literally Speaking
Preparation: Before class, cut out newspaper headlines for students to choose from.

122. Changing Surface Quality
Preparation: Provide enough magazines so that each student can choose a large color image to work with. You may want to ask students to bring in magazines a few days before doing this activity.

123. Masking Tape Resist
Extension: Once the paint is dry, have students work into the negative spaces with a fine-point marker or pen and ink.

Materials and Techniques

125. Solution Versus Saturation
This is an excellent activity to use as an introduction to color mixing because it demonstrates that combining several different colors will produce something that looks black.
Preparation: Before having students do this activity, you may want to check your markers to make sure the black ink will separate into its component colors. Mister Sketch watercolor markers work particularly well for this activity because they use several different pigments to create black.

Background: Most nonpermanent markers use inks that are made up of colored pigments. When the marker gets wet, the water dissolves the pigments on the filter paper. The black ink separates to show the colors that were combined to create black. Different colors are carried at different rates. Depending on the pigments in the markers students use, they may see blues, greens, reds, and oranges as the pigments separate. The technique of separating colors is called *chromatography*. It is believed that the ancient Egyptians used papyrus for paper chromatography of plant pigments.

Extension: Do the same activity with different colors of markers, including secondary and tertiary colors. Some markers will separate out into the primary colors that were combined to make them.

126. **Look Closely**
Student lists will vary. Sample answers: disposable towels to mop up spills; wrapping presents; money;

training house pets; fans; confetti; sewing patterns; wall covering; lampshades; papier maché.

Extension: Encourage students to discuss other aspects of paper, asking questions such as these: When and where was paper invented? Before that, what did people write on? How many times a day do you throw away something made of paper? How long must a tree grow before it can be harvested and used for paper pulp?

127. **Book Making**
This activity can be used as an introduction to an in-depth unit on handmade books, or can be used to prompt students to look with fresh eyes at something they handle every day.

128. **One Square at a Time**
Preparation: This activity works best with photographs that use large, simple shapes rather than lots of small detail. An alternative approach is to photocopy a one-inch grid onto transparency film. Students should use masking tape to attach the

photograph to a drawing board or other surface, and then tape the transparency grid over the photograph.

Extension: Students can use this technique to enlarge the original image by copying the original square onto a bigger square. That is, if the square in the original image is 1 inch by 1 inch, have students draw a 2-inch square on the blank paper, then copy the lines from the smaller square onto the bigger one.

129. **Trompe l'Oeil**

Background: Cornelius Norbertus Gijsbrechts (1610?–1675?), Flemish painter known for trompe l'oeil works.

Preparation: Provide students with a selection of magazine photographs to choose from. Large images with plenty of detail work well for this activity. You may want to ask students to bring in magazines a few days before doing this activity.

130. **Still Life**

Preparation: If possible, show students reproductions of still lifes before they start this activity. Make sure students have a variety of objects to combine in their still lifes. Objects can include books, pencils, fruit, shoes, pieces of fabric, cups, vases, and so forth. Students can work in small groups, each drawing the same still life from a different angle.

131. **Horizon Lines**

Preparation: If possible, before students start this activity, show them reproductions of landscapes with different horizon lines.

Art Appreciation

132. **Postcard Time Line**

Preparation: Provide students with postcards or small reproductions that cover a range of periods. Students may work on this project individually or in small groups. Answers will vary, depending on the reproductions each student or group uses.

133. November 18, 1879

Answers will vary. Sample answers: Elements of design: the paintings show a strong use of line and color; Principles of design: There is good contrast between the cave walls and the animals. The animals are painted so that they appear to be moving. Reasons for creation: perhaps ritualistic, to ensure a good hunt, or spiritual—the animals represented totem animals for the people living there; Types of tools: brushes made of sticks and animal hair, hollowed-out bone straws for blowing, chewed stick brushes.

134. Contour Cave Images

You may need to remind students that contour drawing is essentially drawing the outline of the subject.

135. Prehistoric Figures

Answers will vary. Sample answer: Perhaps it was considered bad luck to capture a person realistically. Perhaps the people were shown in ritualistic costume.

136. The Tigris and Euphrates Rivers

Preparation: If possible, provide copies of maps showing both the ancient Assyrian and Persian empires and the lands that are located in this area today (Turkey, Iraq, Iran, Kuwait, Saudi Arabia).

137. Ancient Extreme Sports

Preparation: If possible, show students reproductions of the "Bull Leaping" fresco described in the student activity.

138. Life After Death

Preparation: If possible, show students reproductions of ancient portraits that use twisted perspective.

140. Fabulous Fibula

If you do not have images of fibulas available, try looking in the dictionary, an encyclopedia, or on the Internet for images so that students can see how a fibula was constructed.

141. Chinese Painting

Preparation: Examples of Chinese bamboo or

orchid paintings can help show students how simple strokes can create something beautiful.

142. **Mosaics**
Preparation: Prepare enough paper "tiles" to give students a good selection of colors.

143. **Illuminated Manuscripts**
Extension: Have students create an illuminated painting.

144. **Andrea Mantegna**
Background: Andrea Mantegna (1431?–1506), Italian painter and engraver, known for heroic figures painted from a dramatic perspective that gives the viewer the illusion of looking up from below

145. **Albrecht Dürer**
Background: Albrecht Dürer (1471–1528), German painter, printmaker, draftsman, art theorist; often considered the greatest German artist of the Renaissance period

146. **Michelangelo**
Background: Michelangelo Buonarroti (1475–1564), Italian sculptor, painter, architect; greatly influenced development of Western art

147. **Arcimboldo Portraits**
Background: Giuseppe Arcimboldo (1527–1593) was an Italian painter who is best known today for a series of portraits made up of a variety of objects such as fruit, leaves, animals, coral, pearls, and so forth. Students may see a connection between Arcimboldo's portraits and the photo mosaics often seen today, where tiny squares from other images are combined to create a realistic portrait or copy of another image.
Extension: Have students use clay to create a portrait using fruit in the place of facial features. You may cast real fruit and vegetables in clay, or have students model the objects themselves.

148. **Rembrandt's Etchings**
Background: Rembrandt van Rijn (1606–1669), Dutch painter, draftsman, etcher, teacher; known for mastery of light and shadow, especially the

technique of *chiaroscuro,* which uses light and shade to create a sense of three-dimensionality
Preparation: Used CD cases are an inexpensive source of Plexiglas. Use pliers to snap the edges off the cases. The resulting flat panels are a good size for these "etchings." If you use CD cases, change the final step of the activity. Have students place the CD case over the damp paper and use a brayer to apply pressure. Because of the ridges on the CD case, the case may crack if the ridges are against a flat surface. Make sure the drawing paper for student prints is damp but not sodden. If the paper is too dry it will not pick up the ink from the scratched lines; if it is too wet it will be hard to work with.

149. **Canvas Captions**
Background: Jan Vermeer (1632–1675), Dutch artist known for sensitive paintings showing figures in interior settings; Diego Velázquez (1599–1660), Spanish painter known for his portraits of courtiers; he also painted landscapes, mythological and religious subjects, scenes from common life.

150. **Realism in Art**
Background: Francisco de Goya (1746–1828), Spanish painter whose paintings, drawings, and engravings reflected the turbulent history of his time, including Napoleon's invasion of Spain; Honoré Daumier (1808–1879), French caricaturist, painter, and sculptor whose work often involved political and social satire, depicting current events and human folly without sentimentality

151. **Jean-François Millet**
Background: Jean-François Millet (1814–1875); French painter known for his paintings of peasants at work

152. **Thomas Cole**
Background: Thomas Cole (1801–1848), English-born American painter known for romantic landscapes, allegorical paintings; dubbed the founder of the Hudson River school

Preparation: If the view from your classroom is not appropriate for this activity, provide reproductions or transparencies of landscape photographs.

153. Color Patches
Background: Paul Cézanne (1839–1906), French painter considered one of the forerunners of modern painting; painted mostly still lifes and landscapes. His work is characterized by his bold use of color and decisive brushstrokes.

154. Claude Monet
Claude Monet (1840–1926), French painter; one of the founders of Impressionism; known for multiple studies of the same subject at different times of the day

155. Weather-Inspired Movement
Background: Vincent van Gogh (1853–1890), Dutch painter known for striking color, contoured forms, rough brushwork; influenced Expressionist approach to art

156. Georges Seurat
Background: Georges Seurat (1859–1891), French neo-Impressionist who applied his study of color theory to painting with a technique called *pointillism*, which uses small dots of different colors on the canvas, relying on the eye of the viewer to blend the colors

157. Musical Inspirations
Background: Wassily Kandinsky (1866–1944), Russian-born artist who linked painting and music, associating tone with timbre, hue with pitch, and saturation with volume. He even claimed that when he looked at color he heard music. (This kind of combining of sense impressions is called *synesthesia*.)
Preparation: Choose a recording of music that you think creates a mood or emotion. Selections that work well include Mozart, Vivaldi, and so forth. Play the recording for students. Encourage them to listen to it for a minute with their eyes closed so

that they can focus on what they hear, not what they see.

158. **"Wild Beasts"**
Background: Fauvism was a short-lived movement. Well-known practitioners included Henri Matisse (1869–1954), Maurice de Vlaminck (1876–1958), André Derain (1880–1954), Albert Marquet (1875–1947), Georges Rouault (1871–1958), Raoul Dufy (1877–1953), and Georges Braque (1882–1963). By 1908, many Fauves had moved on to Cubism.

159. **Piet Mondrian Collage**
Background: Piet Mondrian (1872–1944), Dutch painter who contributed to the development of abstract painting. He is best known for paintings that broke the canvas into a series of rectangles, outlined in black, with some rectangles filled with pure colors.

160. **Analytical Cubism**
Background: Cubism developed between about 1908 and 1912. Principal artists in the short-lived movement were Spain's Pablo Picasso (1881–1973) and France's Georges Braque (1882–1963). Cubism stressed abstract form over elements such as perspective, foreshortening, and modeling that were traditionally used to create the illusion of three dimensions. Cubist painters aimed to capture the essence of an object by showing it from multiple points of view at the same time.
Extension: Have students add color to their drawings. Remind them that the color and value of the object change as the student's perspective changes.

161. **Murals**
Background: José Clemente Orozco (1883–1949) and Diego Rivera (1886–1957), Mexican painters and muralists

162. **Marc Chagall**
Background: Marc Chagall (1887–1985), Russian-born painter who worked in France; known for dreamlike paintings where figures seem to float in space

163. **Georgia O'Keeffe**
Background: Georgia O'Keeffe (1887–1986), American painter known for huge abstracted paintings of flowers, bones, animal skulls.
Preparation: You can create simple viewfinders for this activity by cutting a 3-inch-by-4-inch rectangle of cardboard, then cutting a 1-inch-by-1 1/2-inch rectangle out of the center of the larger rectangle.

164. **Alexander Calder**
Background: Alexander Calder (1898–1976), American artist who introduced movement to sculpture with his mobiles
Extension: Have students use thin pieces of metal and fine wire to create mobiles. Make sure the edges of the metal pieces are covered with tape to protect students from sharp edges.

165. **Louise Nevelson**
Background: Louise Nevelson (1899–1988), Russian-born American Abstract Expressionist sculptor

166. **Mark Rothko**
Background: Mark Rothko (1903–1970), Latvian-born American painter known for huge color field paintings made up of bright bands of colors

167. **Jacob Lawrence**
Background: Jacob Lawrence (1917–2000), American painter associated with the Harlem Renaissance of the 1920s and 1930s

168. **Roy Lichtenstein**
Background: Roy Lichtenstein (1923–1997), American Pop artist known for comic-strip style paintings, some of which included speech balloons

169. **Faith Ringgold**
Background: Faith Ringgold (1930–), American artist and writer best known for painted story quilts that combine painting, quilted fabric, and storytelling
Extension: Have students use paper to create a quilt-like collage.

170. Environmental Art
Background: Robert Smithson (1938–1973), American artist known for monumental installations made from rocks and earth, which he called earthworks; Christo (1935–), Bulgarian-born American artist who moved from sculpture to enveloping existing elements in fabric. Projects have included wrapping the Reichstag (Parliament building in Berlin, Germany) in hundreds of yards of fabric, and surrounding eleven Biscayne Bay, Florida, islands in millions of square feet of bright pink fabric.

171. Andy Goldsworthy
Background: Andy Goldsworthy (1956–), British artist known for using the materials he finds in a location—twigs, leaves, stones, snow, ice, reeds, thorns—to create ephemeral sculptures

172. Pop Art
Background: The Pop Art movement began in Britain during the 1950s and moved to the United States. Artists focused on images from popular culture such as billboards, comic strips, and magazine advertisements. Leading Pop artists include British artist Richard Hamilton (British, 1922–) and American artists Andy Warhol (1928?1930?–1987), Roy Lichtenstein (1923–1997), Claes Oldenburg (1929–), Jasper Johns (1930–), and Robert Rauschenberg (1925–).

174. Symbols as Art
Background: Keith Haring (1958–1990), American artist whose work used bold lines simple shapes, and symbols

175. Artful Idioms
Preparation: If you wish, write idioms on slips of paper before class, and then let students draw a slip to work with. Use a dictionary of idioms, or search for websites that list idioms.

176. Op Art Line Drawing
Background: The Op Art (short for "Optical Art") movement, which developed in the United States and Europe in the mid-1960s, was